HAWAI'I
BEER

For Jen —
Mahalo nui loa for
your support & friendship!

HAWAI'I
BEER

 A History of Brewing in Paradise

With
Aloha

PauLKan

PAUL R. KAN

Foreword by Tim Golden

AMERICAN PALATE

Published by American Palate
A Division of The History Press
Charleston, SC
www.historypress.com

The skyline of Honolulu, Oahu, Hawaii. *Courtesy of Carol M. Highsmith's America, Library of Congress, Prints and Photographs Division.*

Aerial view of Honolulu, Hawaii. *Courtesy of Carol M. Highsmith's America, Library of Congress, Prints and Photographs Division.*

First published 2021

Manufactured in the United States

ISBN 9781467146272

Library of Congress Control Number: 2020951664

Contents

CONTENTS

FOREWORD

I love beer. Sure, lots of people love beer, but I love more than just the liquid we drink. Beer has history. Beer has stories. Beer brings people together. I love it so much that I've made it my life.

I grew up on Oahu, Hawai'i, during 1980s and 1990s. I had it good. I spent my youth at the beach, swimming, fishing and getting sunburnt year-round. I have vivid memories of helping my dad do yard work in the blazing sun every weekend. While I cooled off with a cold Passion Orange Juice, my dad always had a cold beer in the fridge. Back then, there wasn't much beer actually brewed in Hawai'i. The glory days of Primo were long gone, and the adults always had domestic light lagers. I remember brands like Coors, Olympia, Rainer and Miller Lite. It was a low point for beer brewing in the state, but those decades without any real presence of locally brewed beer inspired and drove our current renaissance of brewing.

Like many who grew up in Hawai'i, I had to travel and eventually move off the island to experience the world of beer. I learned and tasted many different kinds of beers in other states and countries. I also was lucky to have an older brother who traveled the West Coast and was into home brewing and beer in general. He exposed me to beers that were different from the typical light lagers in green bottles that were ubiquitous in Hawai'i in the late 1990s and early 2000s. If someone would have asked me about local Hawai'i beer back then, I honestly wouldn't have been able to tell them much more than there was once a beer called Primo and that we then had Kona Brewing Company.

My love and appreciation for beer blossomed while I was living in California. I was surrounded by the craft beer boom and had the chance to visit dozens of breweries. I had found my passion; though, at the time, I didn't think I'd actually work in the beer business one day. But, in 2012, I found myself moving back to Hawai'i and jumping into the beer scene. For many years, I have written extensively about the beer culture in Hawai'i, and I have become friends with many of the brewers who are transforming the landscape.

The history of brewing in Hawai'i has largely gone untold, much like the history of Hawai'i in general. In this book, Paul is bringing to life the untold history and stories of beer in Hawaii. Even for most *kama'aina*, this history is unknown and has been lost. It's an important part of the Islands and our home.

Beer is part of the social fabric of our Islands, and in many ways, we tend to look at beer the same way many Germans, English or Czechs do. We love a great beer, don't get me wrong, but the company and talking that happens around the beer is so much more important. We share stories, talk about our lives, our community and family drama while sharing a beer or two. Unlike Europe or many other parts of the United States, we do not have a pub-drinking culture. Instead, we get together at someone's house, in a carport or at a beach park to talk story and enjoy life, all with a cold beer in hand.

The history of beer in Hawai'i is fascinating and important, but Paul also explores our present brewing phenomenon, which has swept across the state over the past fifteen years. As the owner of Hawaii's premiere beer shop and taproom, I've witnessed firsthand how a few brave and innovative brewers have transformed the brewing landscape here forever. We are no longer stuck with one or two bland-tasting light beers. The beers being brewed in Hawai'i are as diverse as the land and the people who call this amazing place home.

Whether you're a local or tourist, beer geek or just someone who enjoys a cold one, Hawai'i's past, present and future of brewing is thrilling and full of life, just like life in the Islands.

So, sit back, crack open a cold beer and let Paul take you on a trip to paradise.

Timothy Golden
Co-owner, Village Bottle Shop and Tasting Room

Preface

Aloha! I'm Paul; I love Hawai'i, and I love beer! When you think about it, Hawai'i and beer fit together perfectly. Having a beer after a day swimming or surfing at the beach is awesome. Being surrounded by the sounds of waves breaking, the sight of birds flying and the feeling of the sun on your skin only makes the taste of beer that much more special. Who hasn't cracked open a cold one and just gazed at the magic of our island paradise? Even if you haven't, this book will make you want to.

Growing up on the Windward side of Oahu, I learned there's beauty in every day, from walking to school under the majesty of the Ko'olau Mountains to swimming in the surf at Waimanalo Beach, from the smell of plumerias in a neighbor's yard to the love of my *ohana*. I remember my high school friends and I used to take the Pali Highway into "town" (how we referred to Honolulu) to enjoy a few beers at Ala Moana Beach Park when the state drinking age was eighteen. We'd kick back, watch the sunset and figure out what bar or club to hit afterward.

Even though the tides of life have taken me to spend most of my time on the Mainland, Hawai'i is always on my mind when I'm away. As a co-owner of a craft brewery in Pennsylvania, I pride myself in knowing that my beers are brewed and served with the Aloha spirit. My brewery's beers are made with respect for nature; plus, the doors of the taproom warmly welcome everyone. For people from Hawai'i, we know that we can be "local" no matter where we are. Just get us together anywhere across the globe, and

we'll "talk story" in Pidgin until midnight—and usually with a cold beer in our hands. We "live Aloha." The coronavirus has made it difficult; social distancing does not come naturally to us, but we continue to be a strong community, and beer has helped.

I decided to write this book not only because of the love I have for my home state and its beer, but because all the books about the history of American beer never mention Hawai'i and its brewing tradition. Like so many people from Hawai'i, when our state and our people are overlooked, I always feel the urge to say, "Hey, we're part of America, too!" Just because Hawai'i is the most isolated island chain in the world, that doesn't mean a beer tradition has passed by its shores. The last state in the Union shouldn't be left behind when it comes to talking about brewing great beer. In fact, we've been riding the wave of local brewing since Hawai'i was a kingdom. Plus, it was a Hawai'i brewery that made an important contribution to the brewing industry. The aluminum can was an innovation from Primo Beer in 1958. All Americans should say *mahalo* to Hawai'i for that!

In today's craft brewing movement, there are several ways that Hawai'i stands alone in the United States. For people who like a tropical IPA, they should have one in the only state in the tropics. In addition, out of all the states in the Union, we have the westernmost brewery (on Kauai). If you drink a beer at Kauai Island Brewing Company and head due west, you'll hit the international dateline, and you would be drinking your next beer sometime the next day in Asia. Hawai'i is also the state that has the southernmost brewery (on the Big Island). If you drink a beer at Kona Brewing Company and then head due south, well, with a lot of luck, your next beer may come from the supplies, or a creative home brewer, at a science station in Antarctica.

Hawai'i is truly a special place, and our beer tradition reflects it. This book is a "mixed plate" of stories about the beer of our Islands. It's a blend of the history of Hawai'i's early brewing experience and a tour of today's craft brewing movement. In this book, we'll talk about the challenges and triumphs of making beer in the middle of the Pacific. In part I, we'll look at the early years of brewing in Hawai'i and how our state's unique *aina* (land/geography) led the first brewers to adapt and improvise. In part II, we'll go *holoholo* (casually roam) around the Islands to check out how their different cultures imbue today's craft brewing scene. You can take this book with you when you visit our Islands' craft breweries; chapter five is formatted like a guidebook, with space for you to take notes. In part III, we'll "talk story" (hangout and chat) with some of those people who are

making Hawai'i a true paradise for beer lovers. The flow of this book is planned like a laidback Hawaiian day—enjoying the beauty of the *aina* by going *holoholo* with friends and family to talk story about our day afterward.

So, whether you're a *kama'aina* or a visitor to Hawai'i, let's find a cool place in the shade, pour a local brew and appreciate everything it took to make that beer a part of paradise.

Acknowledgements

Mahalo

(Thanks and Gratitude)

Writing a book and brewing beer have some things in common. Both require patience; there's lots of trial and error; and it helps to have good people around to put the ingredients together. I am deeply grateful to the following people who helped make writing this book a real joy. My editor, Laurie Krill, took a chance on green lighting this project at The History Press. My colleague Patrick Bratton at the U.S. Army War College helped put me in touch with the right people to understand Hawaiian history. Tracy Chan gave me a hand in knowing who in the Hawaiian craft brewing industry I should initially approach. Cindy Goldstein and Tim Golden were my patient tutors and guides; they've been fantastic. Doug Askman added his scholarly weight to the effort. Allan Spitzer was gracious enough to share his family history and photographs from the early years of Primo Beer.

All of today's brewers and brewery owners who I met along the way— Nate Anderson, Nick Wong, Dave Campbell, Geoff Seideman, Keaka Eckert, Kyle MacDonald, Steve Haumschild, Mattson Davis, Kim Brisson-Lutz, and Garrett Marrero—really embraced this book project. I also spent a lot of time on barstools; I am grateful for the patience of all the people who sat next to me and had to listen to me talk about the history that I was uncovering.

I couldn't have been luckier to have the love and support of my Mainland *ohana*—Angie and Lily Bistline, Noah "Jumpstreet" Reighard, the Arnold Family, Rick Galena, Jeanette Moyer, Nancy Sneed, Joel Hillison and Thomas Laughman. My brewery *ohana* at Burd's Nest Brewing Company

were great morale boosters when I took on this project: Dave Hamilton, Sydney Durenberger, Pam Mountz and Jim and Diane Curtin.

And, of course, my *ohana* in my home state of Hawai'i has been a blessing—to my mother, Elwyn; sister, Monique; brother-in-law, Kevin; and nieces, Janae and Kiani, thank you for your love and support (*mahalo i ko'u 'ohana no ke aloha me ke kāko'o*).

Introduction

Ho'omaka

(To Begin)

Few people know that the first beer brewed in Hawai'i wasn't made on land. It was made offshore on the HMS *Resolution* in late 1778, when the ship was anchored at Kealakekua Bay, just off the coast of the Big Island of Hawai'i. It didn't go well. Believing that beer helped prevent scurvy, Captain James Cook of Britain's Royal Navy ordered a brew to be made from sugarcane and hops.[1] It did not receive positive reviews. The crew wrote a "mutinous letter" to Cook, saying that the brew had "an injurious effect on their health."[2]

Cook did not take the criticism of his beer well. After reading the letter, he ordered the crew to gather on the aft deck of the ship, where twenty marines, with their weapons at the ready, surrounded them. In order to entice the crew to rethink their opinions of the beer, Cook announced that he would be cutting their brandy rations.[3]

The ship's barrel maker, tired of drinking only water, did break into a barrel of the fermenting beer. He was caught and received a dozen lashes as punishment.[4] All in all, the first brewed beer in Hawaii didn't taste great. Its drinkers preferred taking a risk of contracting scurvy, but at least it was better than water—if a lashing could be avoided. Then again, Cook wasn't making a brew to win a gold medal at a craft beer festival; he was doing it as a matter of survival.

Cook never had the chance to improve his recipe. A few short weeks later, a group of Hawaiians killed him in a dispute over a theft, not as a reaction to his apparently terrible beer. We don't actually know whether his brew was

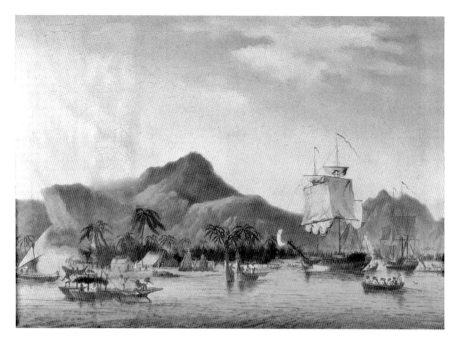

The HMS *Discovery* and HMS *Resolution* in Kelakekua Bay in 1778. *Courtesy of Wikimedia Commons.*

ever brought ashore for the Hawaiians to have what would've been their first taste of brewed beer.[5]

Captain Cook's voyages to the "Sandwich Islands," as he named Hawai'i, marked the beginning of the Islands' contact with the rest of the world. Cook may have brewed his unconventional (and unpalatable) beer nearly 250 years ago, but when brewing finally traveled over the surf and onto the land, it became firmly rooted in Hawai'i's history. The journey of beer making in Hawai'i, from the past until today, has been filled with challenges and triumphs that have not been experienced anywhere else in the world— because Hawai'i is like nowhere else in the world.

"HOME IN THE ISLANDS. HOME IN THE MIDDLE OF THE SEA."

As the lyrics above from the Brothers Cazimero song tell us—Hawai'i is an amazing place. Our state is in the center of the world's oldest ocean, which

contains the youngest lands, including the ever-growing Big Island of Hawai'i.[6] The Pacific Ocean is so vast that all the Earth's land combined can be put inside it.[7] This all makes brewing beer in Hawai'i an amazing feat. There are breweries just miles from an active (and, at times, violently erupting) volcano; these same breweries also lie in the shadow of the highest base-to-summit mountain on the planet—Mauna Kea. Meanwhile, craft breweries on Kauai are downslope from Mount Waialeale, which is the wettest place in the world.

Hawai'i's location makes its beer history full of adventure. Much like the original people who settled all over Polynesia, Hawai'i's brewers are voyagers, dreamers and innovators. Their spirit is the spirit of Hawai'i. It is the *aina* (the land) and the people's connection to it that makes our beer special and unique.

People in Hawai'i have a strong connection to the *aina*; it orients us in deep and often unconscious ways. We give directions using *makai* (toward the ocean) and *mauka* (toward the mountains) rather than north, south, east and west. The legends and lore of ancient Hawaiians reflect this strong link to the land and continues to be a facet of life in the Islands. For example, people who live in Hawai'i all know to not take lava rock from the Big Island and invite bad luck from the goddess Pele. Certainly, the visitors to Hawai'i have learned this lore—every year, Volcano National Park receives thousands of lava rocks in the mail from tourists who have found their lives negatively affected after bringing these "souvenirs" home with them. Flower leis are routinely given and worn at special occasions, like birthdays, graduations, promotions and weddings. These intimate ties to nature are reflected in our state's beer. Native ingredients are used to flavor other imported ingredients that must travel here from distant places. Water purified through volcanic rock, along with local fruits and other plants nurtured in rich soil, infuse our local brews with the spirit of the *aina*.

Local Diversity and the Diversity of "Local"

As one beer historian put it, "Beer, like America, has prevailed not because of uniformity, but rather diversity—it has always allowed for interpretation at the local and regional level to accommodate it."[8] Nowhere is this truer than in Hawai'i; we are one of the most diverse states in the Untied States, in terms of both ecology and demography. Beer doesn't just happen; people put ingredients together to do the brewing (and the drinking, too).

To understand the people of Hawai'i, it helps to know that we are a blend of many ethnicities. Hawai'i is a "majority minority" state; there is no ethnic majority in our state. Generations of immigration have made us more than multicultural. Many people in Hawai'i are of mixed heritage and ancestry. It is not uncommon to find someone who can trace their family back to peoples of European, American, Asian, Pacific Island and even Caribbean decent. Naturally, many families can also trace their ancestry back to the Native Hawaiians. Arriving in the Islands in successive waves from the Marquesas and Tahitian Islands beginning around 400 CE, Native Hawaiians, or Kanaka Maoli, created a rich culture that permeates the state's modern society, traditions and politics. Native Hawaiians, however, continue to struggle for recognition of their rights in the shadow of decades of exploitation, exclusion and marginalization.

Calling Hawai'i home is what keeps us all together. Our identity is wrapped up in our geographic uniqueness. Labeling someone or something as "local" has both a cultural meaning and a spatial reference.[9] A local (someone whose home is Hawai'i) can drink a local beer (something made in the state). In Hawai'i, as in many other places around the world, eating and drinking are an integral part of culture, identity and meaning. A visitor to Hawai'i doesn't automatically become local when drinking a local beer. There are habits, speech and traditions that imbue our meals and socializing that someone from outside of Hawai'i wouldn't know or understand. But eating and drinking products from outside the Islands have still been included as part of Hawai'i's identity. A local who prefers drinking a Mainland or imported beer does not suddenly stop being a local. We can see this in the beer preferences of locals throughout the latter half of the twentieth century—while Grandpa may have drunk locally owned Primo Beer, Dad probably ended up drinking Heineken after Primo left the Islands.

Having a Dutch beer like Heineken become part of local culture shows how Hawai'i adapts to its place in the world by blending a number of cultures together as a matter of routine. We take our shoes off before entering a house, as is customary in Asia. The ukulele, which is very much a part of local music, came to us from Portugal. Pidgin English, (or "Hawaiian Creole English" as the U.S. Census Bureau calls it) is a mishmash dialect of words, grammar and intonations from several languages. Many things we consider "local" were adapted from other cultures and then adopted as our own.

The best description of how beer came to be part of Hawai'i's culture is that it was "naturalized." Rather than a homegrown drink, which evolved separately from other regions of the globe with the occasional addition of

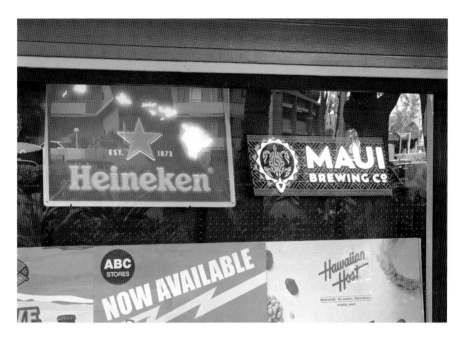

A store window highlights the battle of "local" beers in Hawaii. *Photograph by the author.*

plants and techniques from elsewhere, beer brewing in Hawai'i has been like a cuisine that was "carried over long distances by migrants, naturalized in places far from their origin, and often layered on older, established cuisines."[10] How better to describe the journey of an alcoholic beverage that was first produced five thousand years ago in Mesopotamia, made a staple of German Oktoberfests and which has become part of a remote island chain's culture? Hawai'i has definitely naturalized beer. As a state, Hawai'i is ranked twentieth in per capita beer consumption. Surprisingly, Hawai'i consumes more beer than Minnesota, Illinois, Pennsylvania or the craft beer paragon of Colorado.[11] And today's craft brewers in the state produce more beer per capita than those in Illinois, Maryland or New Jersey.[12] In fact, our brewing history is older than that of the "beervana" of Portland, Oregon. This isn't bad for the most isolated archipelago on the planet.

However, given Hawai'i's location, it is virtually impossible to make a local beer with all indigenous ingredients. Like many other places, the term "local," when applied to food and drink in Hawai'i, has evolved to include other desirable features, such as small-scale or organic ingredients.[13] None of this has prevented debates in the state over what is—and what should be—labeled "local" beer.[14]

Debates aside, respect for the environment and sustainability are also desirable features of today's local brewing in the Islands. Key beer-making ingredients that are brought to the state are subject to rigorous laws and scrupulous inspection. The delicate biodiversity of the Islands is highly prized. Hops shipped to Hawai'i cannot contain any other organic compounds that might harm the Islands' lush flora. The same goes for yeast; certain strains are not permitted to enter Hawai'i for fear of ruining key parts of the state's ecosystem and agricultural economy. Today's craft brewers in Hawai'i also see themselves as stewards of the Islands' environment. Brewers on Oahu support groups like Waterkeepers Hawaiian Islands, which seek to improve ocean quality by returning native oysters to their namesake waters, Pearl Harbor. Again, beer in Hawai'i is not only about relaxation and pleasure; it's about respecting the *aina*.

THE ISLANDS AT THE EDGE OF AMERICA

Regardless of where alcohol has been produced and consumed, it has always been caught up in politics. How liquor is made, distributed and consumed has been subject to the whims of governmental policy. Beer has been no exception, and in that respect, Hawai'i is not unique. Beer in Hawai'i has survived the Islands' ever-changing political fortunes—from kingdom to short-lived independent republic and then to becoming a U.S. territory and eventually state. The political history of Hawai'i has had many rip currents; beer brewing has often been caught in them and has struggled to break free.

Unlike the beer traditions in other states in the United States, Hawai'i's began under the rule of a kingdom, not a colony or territorial government of a distant kingdom. The Hawaiian monarchy was an ever-present political force as beer brewing began in the Islands. The Kingdom of Hawaii was a sovereign nation recognized by other nations (including the United States); there were no "absentee landlords" or "colonial governors" that ruled its people. In this respect, Hawai'i once again stands alone in the history of other U.S. states. This monarchical tie, along with subsequent oligarchic commercial interests that led to the overthrow of the Hawaiian monarchy, affects Hawaiian beer brewing to this day. Legacies such as land trusts, large landowners and state ownership have prevented small entrepreneurs from entering the state's agricultural sector, which could bolster and diversify the ingredients brewed in local Hawaiian beers.[15]

Another important legacy of Hawai'i's political history is the economic influence of different populations that have arrived here over time. Governments in Hawai'i have had to juggle a rich variety of people coming to the Islands. Traders, whalers, missionaries, businessmen, plantation workers, military troops and, of course, tourists have all been part of the political backdrop, and they've shaped Hawai'i's beer tradition. Styles of beer changed as Hawai'i welcomed a greater number of foreigners; large-scale commercial brewing grew along with American influence and capital in the Islands.

Americans brought the first large-scale commercial brewery to Hawai'i. The promise of thirsty customers must have been great. Honolulu Brewery was established in 1854, meaning that beer was flowing from its production line before the Islands' first daily newspaper was printed, before money was loaned from the Islands' first commercial bank and before ships were guided into Honolulu Harbor via the beams of the first lighthouse. The brewery predated the building of some of Hawai'i's most iconic historic landmarks like Queen's Hospital, St. Andrew's Cathedral and 'Iolani Palace. Historically, although commercial beer production arrived later in Hawai'i than it did in other parts of the United States, it began at the same time as brewing in Mexico and China.[16]

Commercial brewing may have been driven by the quest for profit, but beer drinking was relegated to the lower end of the social-political ladder. The kingdom permitted the brewing and sale of beer, but the aristocracy did not view beer consumption as worthy of incorporation into their lifestyle. The Hawaiian monarchy in the mid-nineteenth century took on the eating and drinking habits of European monarchies and American tycoons. We can see this through what was included (and not included) in the menu of King David Kalakaua's 1874 coronation:

> It proceeded from mulligatawny, turtle, Windsor, and á la Reine soups, through fish, and meats, such as wild duck, pheasant, fillet of veal, turkey with truffle sauce, beef á la mode, ham, roast goose, and curry, followed, served with potatoes, peas, tomatoes, corn, asparagus, spinach and taro. For dessert, guests were offered wine jelly, sponge cake and strawberries and cream. Sherry hock, claret, champagne, port, liqueurs, tea and coffee were served.[17]

Noticeably absent, of course, was beer. This should not be a surprise; beer was for the lower classes, especially traders, merchants and sailors.

Although the Hawaiian monarchy could drink alcohol, this was not always the case for its subjects. The prohibition of liquor in Hawai'i was part of the life of Native Hawaiians before the arrival of New England missionaries (beginning in the 1820s) and before Prohibition in the United States. Yet, prohibition went through cycles of acceptance and rejection. By at least 1935, beer was widespread enough for a dictionary of Hawaiian slang to include an entry for *mimi*—"to make room for more beer."[18] It's not clear if *mimi* meant to make more room to drink more beer or to make room to store more beer. Either way, it shows that beer had become a significant presence in what was, at the time, the U.S. Territory of Hawaii.

Becoming part of America changed beer brewing in Hawai'i. No longer were American beers considered imported or foreign. However, local brewers then had to compete with the influx of what became domestic beers coming from other parts of the United States. As we'll see in chapter 2, Hawai'i took on the challenge by relying on its brewing tradition; beer makers adapted and innovated.

Innovation and adaptation continue to be key attributes of today's craft brewers in Hawai'i. Even in the twenty-first century, when the globalization of supply chains eased many of the geographic challenges of a U.S. state that brews surrounded by the Pacific Ocean, Hawai'i is still on the edge. By one estimate, Hawai'i produces just slightly over 11 percent of its own food and is, therefore, heavily dependent on imports to sustain itself.[19] A harrowing estimate from the U.S. Department of Agriculture demonstrates how close to the edge Hawaii is: "Hawai'i has only a seven-day supply of food at any given time."[20] To keep supplies for beer brewing reliable, Hawai'i brewers routinely pay five times more to move inventory than their Mainland counterparts. Not even the COVID-19 pandemic of 2020 could stop the brewers in Hawai'i. They continued to adapt to changing mandates and customer preferences while helping the local community. A new brewery opened during the stay-at-home restrictions, and several other Hawaiian breweries joined the worldwide "All Together" brewing movement to make a beer from the same recipe, with proceeds benefiting hospitality workers who had lost their jobs because of the pandemic.

Hawaiian beer has become truly national—and international. A beer drinker can find Maui Brewing Company beers on the Mainland, and beers from Kona Brewing can be found in almost forty states and fifteen countries as far away as Australia. Today, Hawai'i's beer is more than local; it has become an international drink. So, although we may never know whether Captain Cook's brew ever came ashore, we know that today's Hawaiian beer

has gone out beyond the breakers of the state's surf and over the shores and many borders of other places to share the love and respect people in Hawai'i have for their *aina*.

In the following pages, we'll explore the unfolding of Hawai'i's brewing tradition in detail. Brewing in paradise hasn't been easy, but now, Hawai'i has become a brewing paradise in its own right. It can even export a little bit of its paradise to other parts of the world by sharing what Kona Brewing calls "Liquid Aloha."

The future of brewing in Hawai'i is as bright as the sunshine of beautiful Hawaiian day. There is no pandemic that could stop the spirit of Aloha. Join the journey as we chart the course of brewing in paradise.

PART I

O Ka Aina (Of the Land)

The History and Mystery of
King Kamehameha's Brewer

I ronically, more is known about Hawai'i's first beer that was brewed offshore than the first beer that was made onshore. Adding to the irony, the first European to make beer in Hawaii wasn't from a country known for its beer tradition. Thirty-four years after Captain Cook ordered the brewing of beer on his ship, a Spanish advisor to King Kamehameha named Don Francisco de Paula Marin noted in his journal that he made beer onshore. But unlike Cook's beer, we don't know what ingredients Manini, as the Hawaiians called Don Francisco, used in his beer, how he made it or whether it was any good. And these aren't the only mysteries surrounding the king's brewer.

Manini was more than a brewer; without him, there might not have been a Kingdom of Hawaii. The finer details of his early life are unknown, and what is unknown or unrecorded often becomes legend or lore. Before his life as Manini, Don Francisco was believed to be the pilot of a Spanish ship, but he deserted it near what is present-day Vancouver Island, Canada. His eventual arrival in Hawai'i is subject to debate. He either hopped on an American vessel bound for Hawai'i or got drunk while helping load a ship with supplies and woke up, surprised to discover that he was on his way to the Islands.[21] The reasons he ended up in Hawai'i will likely never be known, but he brought with him a wealth of knowledge that an ambitious Hawaiian chief named Kamehameha used to his advantage. Manini was able to procure firearms and train Kamehameha's forces to use them against rival island chiefs. With Manini's assistance, Kamehameha

prevailed in the 1795 Battle of Nu'uanu on Oahu that led to the unification of the Hawaiian Islands under his rule.

As a reward, Manini became one of King Kamehameha I's most trusted advisors. He became the king's translator, accountant, tailor and physician. He was so close to the king that he was reportedly one of the last people to attend to Kamehameha before his death. As one of the king's closest confidants, Manini was granted vast acreage in present-day downtown Honolulu, and he was given possession of what is now called Ford Island in Pearl Harbor. On this land, Manini became an active horticulturalist. As one person described him: "Marin was a one-man agriculture experiment station."[22] He introduced many of the fruits that have long since been associated with Hawaii, like guava, mango and pineapple. He also grew avocados, limes, oranges, coffee and many other fruits and vegetables. Vineyard Boulevard in downtown Honolulu is named after the area where he grew his grapes for making brandy and wine.

But did he grow the ingredients to brew beer? He may have. Being from Spain, where wheat beer had been produced since the sixteenth century, Manini may have first thought to make beer from wheat.[23] After all, Manini had experimented with growing wheat in Honolulu. However, the soil and climate were disappointments for cultivating the grain, and it appears that he gave up trying. Manini did grow corn and rice, which also could have been used to make beer. Spanish sailors and soldiers on expeditions routinely adapted and made beer with other ingredients, like corn and rice.[24] As for hops, the tropics were not ideal for growing them, and nothing suggests that Manini ever attempted to plant or harvest hops.

Manini may have improvised and adopted a well-known Russian beer-making technique. Manini encountered many Russian sailors in the region where he deserted his vessel before coming to Hawai'i, and the Russians were a growing presence in Hawai'i during his time as King Kamehameha I's advisor. Russian sailors often fermented bread soaked in water to produce a type of non-brewed beer called *kvass*. Could the first European beer made in Hawai'i not have been brewed at all? It's possible. But it's more likely that Manini, if he didn't grow the needed ingredients, used his trading skills to acquire beer-brewing ingredients in a number of other possible ways. He was away from Hawai'i at times and may have picked them up during his travels. Plus, when in Hawai'i, Manini routinely wrote to ask his friends and acquaintances in California, Mexico and South America to send him plants and seeds, but we don't know for certain if they ever sent the ingredients for making beer.[25] He also met many traders

Portrait of King Kamehameha I. *Courtesy of Wikimedia Commons.*

who were visiting Oahu because, in addition to getting a grant of land, the king permitted Manini to run a saloon and boardinghouse for sailors at the *makai* end of present-day Nu'uanu Avenue near Honolulu Harbor. Manini was in a perfect location to get the ingredients for beer from traders and sailors visiting his saloon and boardinghouse.

Manini's saloon and boardinghouse may also help answer another question of who drank his beer. It probably wasn't the king or Hawai'i's nobility. According to Manini's journal, he and the royal family of the kingdom were often drunk on the brandy and wine he made. In fact, the nobility liked these drinks so much that Kamehameha placed a *kapu* on Manini's vineyard, forbidding anyone to touch it except for Manini and his workers. Perhaps more telling is that, in all his journal entries about drinking with the royal court, Manini never once mentioned beer—nor did the king ever place a *kapu* on anything connected to Manini's beer brewing.

If the royal court was not drinking his beer, the second entry about beer in Manini's journal makes it nearly certain that he was making his beer for seafarers. On December 7, 1815, he wrote, "This day, I made a little oil and a barrel of beer for Captain Tela."[26] "Captain Tela" was Captain John Tyler, the master of the merchant ship *Isabella*, who likely purchased Manini's beer for his crew.

Manini and Captain Tyler appeared to be close friends. In the nights after the beer was made, Tyler and Manini went on a drunken bender together. On one night, Tyler had to carry a drunk Manini back home after a dinner party.[27] On another night, Manini was forced to return the favor—Tyler's drunken antics caused a near riot among the local Hawaiians, requiring Manini to get out of bed and calm them down.[28]

As for the kind of beer Manini made, it was certainly ale and not lager. This is based on another essential ingredient needed to brew beer—yeast. The discovery of yeast as a critical part of the brewing process did not happen until later in the 1800s. Because he didn't use yeast and relied on "spontaneous fermentation," Manini's beer would have been a type of top-fermenting ale. How he made his barrels of beer is also a mystery. There is no record that he had sophisticated brewing equipment and may have relied on rudimentary items to produce wort, separate the grain, move the wort into a mash tun, (possibly) add hops and then move the mix to a fermentation container.

But how did Manini's beer taste? Well, there weren't any potential uprisings, as happened with Cook's brew. That's the good news. The bad news? In an age before the ice trade and refrigeration reached Hawai'i, Manini's ale would have been warm fermented in a wooden barrel. In order for fermentation to occur, he would have tried to keep it somewhat cool. However, even the most careful brewer of the day in the hot conditions of the tropics would not have been able to prevent a top layer of moldy foam forming as the brew fermented. Insects attracted to the fermenting liquid

would also have been an issue. A spontaneous fermenting ale like this one would have been ready to pour in fewer than ten days if it didn't spoil during fermentation. Had Manini been able to add hops, they would've acted as a preservative and allowed for the beer to last a few days. With such little time to ferment, the beer may have only been, at most, 2 percent alcohol. When the beer was ready to serve, it would've been at room temperature. By today's standards, the review of Manini's beer on the beer rating app Untappd would have been brutal.

But in today's Hawai'i, Manini is nonetheless commemorated. While the many mysteries of Manini's beer making are likely never to be solved, he is ever-present in the daily lives of many people who live and work near downtown Honolulu. Marin Tower, a high-rise in Honolulu near the site of his old saloon and Marin Street close to present-day Nimitz Highway are two notable examples of his presence on the island. And although we may not know a lot about Manini's brew, he undoubtedly contributed to the evolution of Hawai'i's history while setting the stage for today's beer brewing in the state. Many of the plants he introduced, like coffee, guava, mango and pineapple, have become familiar ingredients in the craft beers that are still being made around the Islands.

2.

Kingdom Coup

Territory Brew

The first large-scale, commercially made beer in Hawai'i was unlike the brews of either Captain Cook or Manini because it had an unusual quality, or more accurately, it was missing a quality that is usually associated with beer. Its uniqueness was highlighted in the second paragraph of the Honolulu Brewery's inaugural advertisement in the March 25, 1854 edition of the kingdom's official weekly newspaper, the *Polynesian*:

> *Honolulu Brewery—Genuine Beer—The undersigned, having established a brewry* [sic] *in Honolulu, Fort Street, opposite the French Hotel, are now prepared to supply, families, hotels, boarding houses and bar rooms, in bottles or in kegs.*
>
> *This beer is made of barley and hops only—contains no alcohol, nor any ingredients whatever injurious to health—can be recommended to the public as the best and most wholesome beverage ever made on these islands, and we hope, therefore, to obtain the favor of public patronage.*
>
> *All orders will be punctually attended to. Captains and passengers will be accommodated at the shortest notice.*
> —*J.J. Bischoff & Co.*[29]

Indeed, the first mass-produced beer in Hawai'i was a non-alcoholic "near beer." Perhaps in an effort to distinguish itself from imported beers and to avoid the constant tug-of-war between alcohol's prohibition and its acceptance in the kingdom, Bischoff and his partners may have decided to brew a beer that contained no alcohol. They may have sought to appeal

particularly to Native Hawaiians who, during this time, comprised over 95 percent of the population but were prohibited from drinking liquor by the king.[30] The 1850 Penal Code of the Hawaiian Islands, established under the rule of King Kamehameha III, made it clear: "Whoever shall sell, purchase, or procure and on behalf of any native of this kingdom, for his use, any spirituous liquor, or other intoxicating drink or substance, shall be punished by a fine not exceeding two hundred dollars."[31] Whatever the reasons for making a non-alcoholic beer, the owners changed their minds and their inventory; they began to advertise "malt beer" in the *Polynesian*, minus the second paragraph about its non-alcoholic content.

Whether they were making alcoholic or non-alcoholic beer, it was still a pioneering task to found the first brewery in Hawai'i before much of the commercial infrastructure was in place to nurture it. Sadly, the brewery only stayed in business for just under three years. However, bringing the business to the point of rolling beer barrels out of the brewery showed how much had changed in the Islands since Manini brewed a small batch for his rowdy friend Captain Tyler in 1815. It also foreshadowed what would be the perpetual challenges of brewing beer in paradise.

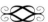

ALCOHOL LAWS IN THE HAWAIIAN KINGDOM, BY DOUG ASKMAN

Alcohol came to Hawai'i with the arrival of Westerners at the end of the eighteenth century. With it also came the problems of alcohol addiction and abuse, especially among Native Hawaiians, who had not been exposed to liquor until the influx of foreigners. Throughout the nineteenth century, various legal policies were enacted to regulate alcohol.

In 1818, King Kamehameha I, seeing the ill effects of liquor on his people, enacted a ban on its production and consumption. His favorite wife, Queen Ka'ahumanu, who wielded great power for over a decade after her husband's death and converted to Christianity in 1825, continued legal prohibitions against alcohol.[32] Laws against spirits were also enacted in succeeding years, but they were not always effective and were often met with stiff opposition, especially from foreigners. In 1839, a

French naval vessel arrived in Hawai'i and threatened to bomb Honolulu unless a series of demands were met, including the permission of French alcohol imports with only limited duty. A decade later, a military incursion by the French contained demands for a reduction of the taxes on French brandy.[33]

In 1865, a bill in the Hawaiian parliament proposed the repeal of the ban on selling or giving alcoholic drinks to Native Hawaiians. While several prominent government leaders favored the relaxation of prohibition, the monarch at the time, Kamehameha V, declared, "I will never sign the death warrant of my people."[34] The bill died before becoming a law. Nevertheless, a proposal prohibiting the sale of liquor to Chinese residents of the Islands failed in 1880.[35]

Despite legal restrictions, Native Hawaiians' access to alcohol was widespread, with a Honolulu newspaper reporting in 1882 that "natives, almost anywhere, can purchase it with the same freedom as those who are not legally barred from using it."[36] That same year, the legislature, supported by King Kalakaua, enacted a law ending prohibition for Native Hawaiians. Opponents of the king saw the legislation as a political ploy to manipulate the electorate by plying them with free liquor. Those who supported the end of prohibition argued that restrictions were meaningless since they were not adhered to and that legal regulation might be better a policy to control alcohol abuse.[37] Prohibition was never again instituted in the Hawaiian kingdom, but for the remainder of the monarchy, the number of legally licensed bars remained small.[38]

DIVIDING THE LAND CREATES BREWERIES AND RIVALRIES

Before Honolulu Brewery began fulfilling orders, beer drinkers in Hawai'i had to rely on imported brews to quench their thirst. But the sea voyages of beer to an archipelago located in the vastness of the world's largest ocean were always perilous. Beer from the western edge of North America had to

travel over 2,400 miles, while beer from New England took months to reach Hawai'i and meant going around South America through the treacherous currents of Tierra del Fuego. Beer coming from places around Europe, Asia and other parts of the Pacific faced similar treacherous journeys. Unlike other alcohol of the time, beer did not travel well. It spoiled easily and was often consumed, traded and lost on the way to its final destination. The records of beer coming through the port of Honolulu in 1843 reveal how little beer arrived in Hawai'i: thirty-five cases, twenty barrels, sixty-nine casks and twenty dozens (pints, quart and gallons).[39] It wasn't much beer for what was a thriving (and thirsty) port city.

At the same time, the port city of Honolulu was becoming more like a distant outpost of New England. The steady arrival of Bostonian whalers, traders and missionaries in the early 1800s meant that Boston took on the same connotation in Hawai'i as it did along the Northwest Coast—it was considered the entirety of the United States.[40] The presence of New Englanders helped account for the types of beer imported to Hawai'i. Beginning as early as 1837, newspapers in Honolulu not only contained advertisements for imported ales, but also for the porters and stouts that people from the Northeast United States favored. Yankees liked the beer that reminded them of home.

Yankee influence also extended to the royal court of Hawai'i. Their influence led to one of the key reforms that gave brewers the ability to take their first steps on the Islands. King Kamehameha III initiated the Great Mahele in 1848, ending the ancient land tenure system of Hawai'i, in which the *ali'i* (chiefs) retained rights over their territorial parcels. The *mahele*, or "division," allowed the land to become private property that could be bought and sold. Businessmen and investors snapped up the opportunities that the new arrangements for property ownership allowed.

Private landownership created opportunities that supported Hawai'i's first breweries. Not only could a company buy land to build a brewery, but the ice importation and storage business also emerged and bolstered beer brewing. When it came to the provision of ice to the Islands, New England once again was at the forefront. Maine and Massachusetts had an active ice trade in nineteenth-century America. In 1850, Hawai'i received its first shipment of ice from Boston via San Francisco.[41] While it's not known if Honolulu Brewery purchased any ice to help condition and store its beer, this is unlikely, as ice shipments at the time were too infrequent and unreliable for brewers in Hawai'i to consistently incorporate cooling into their beer making.

However, eight years after Honolulu Brewery was shuttered, a new style of beer brewing dependent on cold temperatures arrived in the kingdom's capital. In March 1865, Americans Thomas Warren and Willard Francis opened Hawaiian Brewery in Nu'uanu Valley and produced the Islands' first lager, naming it "Hawaiian Beer." The brewing of lager beer was yet another reflection of America in Hawai'i. German immigrants arriving in the United States in the 1840s also brought along their lager-brewing techniques. Unlike the beers from the defunct Honolulu Brewery and the ales, porters and stouts imported from abroad, which were all made in warm temperatures with top-fermenting yeast, lager beer required colder temperatures for bottom-fermenting yeast to work.

Making lager beer had some advantages for a brewery on an isolated land mass. Lagers required less grain and fewer hops to produce a consistent beer. As a result, the Hawaiian Brewery didn't need to rely on large shipments of barley and hops. The advent of fast-moving steamships helped take the fragile lager yeasts across the Pacific with greater ease. Indeed, the brewery's first advertisement mentioned that it had "fresh brewer's yeast constantly on hand."[42] Steamships also aided in the importation of ice, something that brewers needed to cold ferment traditional-style lagers in the tropical climate of Hawai'i. As the owners constructed their new brewery, they had faith in the steady importation of the ice they needed to brew lager in a tropical climate.

The brewery's advertising also noted that its beers were made for Hawai'i's climate and were ready to be delivered around Honolulu for free and could be shipped to the outer islands. The owner also emphasized the pureness of the water he used for brewing: "A fine stream of limpid water flows past my brewery, which for clearness and coolness cannot be surpassed." The advertisement emphasized, no doubt to the relief of the beer's potential drinkers, that "persons do not bathe in this stream."[43]

However, the brewing partnership between Warren and Francis did not last long. Warren quickly struck out on his own, and in less than four months, he was running advertisements for his own brewery, Oahu Brewery. Warren's Oahu Brewery produced both lagers and ales while also promising a prompt fulfillment of orders. The former partnership eventually descended into a heated rivalry between Warren and Francis.

Warren, for his part, proved to be a nineteenth-century version of an expert troll. Instead of using social media and chat forums, he did his trolling in the newspapers. In late September 1865, Warren ran a larger and longer advertisement for his beers just below the one Francis ran for his brewery.[44]

In December 1865, the rivalry was over; Francis lost and put Hawaiian Brewery up for sale. Warren and his Oahu Brewery may have emerged victorious, but that didn't stop Warren from trolling. In February 1866, he placed an advertisement for a brewer after "having already [been] deceived by some calling themselves brewers."[45] Warren was likely referring to his former brewer Henry Flickenstein, who definitely felt the burn—so much so that he bought a personal advertisement to defend himself in the following week's edition of the newspaper, claiming that Warren owed him back pay.[46] The dispute didn't seem to matter because a few months later, Warren put the Oahu Brewery up for sale.

Rivalry, trolling and pay disputes aside, what may have contributed to the closings of the two Honolulu breweries in less than a year was the owners' misplaced faith in a steady supply of ice. Importation of ice during this time in Hawai'i's history was growing ever more sporadic.[47] Without reliable ice, both breweries would have been unable to manufacture consistent supplies of quality lager.

So, when Mark Twain arrived in the Islands in 1866 as young newspaper correspondent, he had to drink imported brews just like everyone else in Hawai'i. The records of beer coming into Honolulu recorded a steady, but paltry, supply: 10 barrels, 16 kegs, 36 hogsheads and 11,621 dozens of ale, stout and porter.[48] By at least 1881, Budweiser had arrived in the Islands. But Hawai'i would have to wait over twenty years before beer flowed from a local brewery again. When it did return, it demonstrated that Hawai'i had traded New England brewing techniques and beer styles for those of the West Coast in unexpected ways.

GOLD RUSH LEADS TO A BEER CRUSH

New England wasn't the only part of the United States that was influencing Hawai'i's politics and economy in the nineteenth century. California also held sway over Hawai'i. After the end of the whaling industry, sugar plantations became a new economic engine for the kingdom. Hawaiian sugar played a large role in the Islands' trade with California, as did other Hawaiian agricultural products, like potatoes, oranges, coffee and molasses. These goods, along with Native Hawaiian labor helped sustain California's mining economy during the gold rush. In turn, many Californians came to Hawai'i, looking for a new life after their dreams of striking it rich were shattered.

With California and Hawai'i already sharing a web of relations that spanned thousands of miles across the Pacific, it was only a matter of time before an innovative California brewing technique came to the Islands—*warm* lagering. It was another brewing innovation of America's German immigrants, and it was a way to get around the harsh mining conditions in California. Germans who moved out west used lager yeast to ferment their beer at warmer temperatures. This beer also was also comparatively quick to make, taking between ten and twelve days from mash tun to glass.[49] It was named "steam beer," perhaps because of the fizz that formed with the extra carbon dioxide that fermenting this type of beer created. Steam beer was a good way to make a lager-style beer in challenging conditions.

So, it came as no surprise that, in 1888, the new National Brewery in Kalihi Valley on Oahu began advertising "steam beer." The first advertisement reflected that this style of beer was already familiar in Honolulu when it claimed that its locally made beer "was supplanting the imported article in popular favor."[50] The advertisement also alluded to the difficulty of brewing beer in Hawai'i's past by stating that the brewery had, "for the first time, solved the problem of brewing in this country a pure, wholesome and palatable B-E-E-R."[51] The beer packed a punch. The kingdom had granted the brewery's owner, Gilbert Waller, a license in January 1887. This was granted under the condition that "the alcoholic strength of the beer be ten percent" because (unbelievably) "a beer of that strength would cheer but not inebriate."[52]

Honolulu was eager for cheer-inducing beer from the National Brewery; the city followed almost every step toward the brewery's opening. The first report of the brewery's preparations mentioned forty tons of brewing machinery arriving from San Francisco.[53] Later that year, a local reporter spied "a large nice-looking two-horse wagon has come for the 'National Brewery.'"[54] Shortly after, the brewery announced it was open to the public for inspection.[55] Then, the following day, a lengthy newspaper article described what was a state-of-the-art facility.[56] To those in Hawai'i, or almost anywhere in the Mainland, Waller along with his brewer, William Furtz, had built an impressive brewery consisting of a five-hundred-gallon wooden tun, a five-hundred-gallon mash tun, a mash machine, a boiling tun, several fermentation tanks and a dry-air refrigerating room for bottling and storage.[57] The water was drawn from a 670-foot-deep artesian well, and the facility also included apartments for the brewery workers.[58]

One person who most certainly didn't live in these apartments and didn't find the brewery cheer-inducing at all was Waller's nephew Gilbert J. Waller. At what were likely awkward family get-togethers, Gilbert J. regularly reminded his uncle that he was not only a Mormon, but he was also the head of the Anti-Saloon League of Hawaii and the Temperance League of Hawaii. As his uncle was busy trying to open his brewing business, he was trying to shut it down.

But this didn't dissuade his uncle Gilbert's efforts to stoke the hype for his product. He and Furtz began delivering samples of their steam beer around the city. The editors of a local newspaper were given a five-gallon keg of the new beer on a Monday. Beginning the workweek with a beer buzz definitely helped with their review; they proclaimed the beer to be "a superior article" and said that the brewery would "fill a long-felt want."[59] Other drinkers disagreed, judging by comments like: "There has been a complaint or two that the beer sent out by the National Brewery Co. is a little flat." To remedy the situation, it was recommended to let the beer "stand for twenty-four hours" and to hold the glass "eighteen inches or more below the tap."[60] The latter part of the recommendation wasn't exactly high praise for the beer's quality. After all, pouring draft beer a foot and half from the tap would have created some head (and a lot of splatter) on even the flattest beer in the world. But, with all the issues worked out less than a week later, "Connoisseurs pronounce[d] the beer good, promising on maturity to be on par with the imported article."[61] The brewery was ready to take orders.

Hopes were high that the new brewery would be a boon to the kingdom's economy. "It is claimed on behalf of this new industry that it will retain a great deal of money now going abroad."[62] It was also hoped that "the product [would] largely supplant sandpaper gin among the masses."[63] Sandpaper gin may sound horrible, but it had some staying power—the National Brewery was put up for auction in 1892.[64] There's no record of whether Gilbert J. celebrated his uncle's failed venture or if Uncle Gilbert blamed his nephew in part for his brewery's closing. But the atmosphere around family get-togethers would likely not have become any less awkward.

The closure of National Brewery occurred in the year before the Hawaiian monarchy was overthrown in a coup. Even as brewers tried to adapt to Hawai'i's location, climate and consumers, the Kingdom of Hawaii saw four breweries open and close quickly. It took Hawai'i becoming a part of the United States for beer brewing to emerge as a more consistent feature of the political, cultural and economic landscape of the Islands.

Hawai'i's First American Beer

The perpetrators of the Hawaiian monarchy's overthrow had strong familial and economic ties to the United States and hoped that the U.S. government would quickly annex the archipelago. The plotters eventually proclaimed the founding of the Republic of Hawaii, with not-so subtle gestures to the U.S., by announcing the new government on July 4, 1894, while flying the American flag on top of 'Iolani Palace. To support the treasury of the new republic, its leaders counted on more than just the plantation economy of the Islands; it counted on stimulating a vibrant liquor industry as well. The new liquor laws of the republic established a detailed listing of the quantities, taxes and fines for the manufacturing and selling of wine, distilled spirits and beer.[65]

Taking advantage of these laws was a wealthy Honolulu industrialist and member of the Republic of Hawaii's senate. Alfred Hocking founded a brewing company in 1898, just as the Republic of Hawaii was preparing for its eventual annexation under the new U.S. president William McKinley. Hocking saw himself as both a brewer and a patriot; he was like the Samuel Adams of Hawai'i. Hocking originally named his company the Honolulu Brewing Company but soon changed its name to the Honolulu Brewing and Malting Company.[66] The cabinet of the republic gave its official permission for the senator's brewing enterprise when it transferred Gilbert Waller's old license from the defunct National Brewery to Hocking.[67] Although Hocking was able to transfer Waller's brewing license, he was unable to transfer the early enthusiasm that had once greeted Waller's brewing enterprise. "So, Honolulu is to have another experiment with a brewery," drolly noted the editors of at least one newspaper.[68] But, once again, there were hopes that any new beer would at least entice people away from "cheaper spirits, much to the advantage of stomachs and pockets."[69]

Hawai'i's stomachs and pockets would have to wait a while longer for relief. While Senator Hocking established his brewing enterprise in 1898, he did not have a building. In 1899, Hocking hired a New York architect who specialized in designing breweries to build an eighty-foot red brick building with an ice-making factory. The building still stands on Queen Street in Kaka'ako today. In 1900, the building was complete and officially became the first brewery in the new U.S. Territory of Hawaii. This meant that Honolulu Brewing and Malting Company became the westernmost brewery in the United States. When the first kegs of its flagship beer, Primo, rolled out from the brewery on February 13, 1901, they were filled with

KA HALE HANA BIA.

E Inu aku ana a Kena—Ke Awiwi mai
nei na Paahana I Hoomaka
Koke ka Hana.

Ke awiwi mai nei na paahana o ka
Hui "Honolulu Brewing Co." e hoopau
i na hemahema i koe o ka hale hana bia
ma ke Alanui Moiwahine.
O keia kekahi o na hana ano nui loa
i ikeia ma Honolulu nei iloko o na la
loihi. He lehulehu na hale pohaku nu-
nui i kukuluia, a he mau hale e ae no
kekahi no na mea hana e ae e pili ana
i keia oihana ano hou loa.
He ekolu hale ke kiekie o ka hale ha-
na hau, a iloko no hoi oia hale hoo-
kahi e hoahula ai na pahu bia.
He mau haole akamai na mea na
laua e kukulu nei i na mikini, a ua ma-
nao laua e pau ana ka laua hana iloko
o keia mau pule iho.

Hawaiian-language newspaper *Ka Nupepa Kuokoa*'s August 24, 1900 article on the construction of Honolulu Brewing and Malting. *Courtesy of www.nupepa-hawaii.com.*

beer that was, officially, made in America. Although Americans had made beer in Hawai'i before, this was Hawai'i's first truly American beer. It was a milestone for the Islands.

Hocking was then on the board of supervisors of Honolulu after the Republic was absorbed as U.S. Territory, and his investors were enthusiastic about the prospects of their new brewing endeavor—so much so that shortly after Primo hit the market, they sought to expand distribution beyond the territory. Because of the United States' growing political and economic presence in the Pacific with its acquisition of Hawaii, Primo was an American product that had the potential to break into markets in Asia. By 1905, the company had found distributors that were willing to sell Primo in parts of Asia. But there was a problem. As Louis Schweizer, the secretary of Honolulu Brewing and Malting Company, stated at the time, "The steamship companies won't make us a rate."[70] In other words, shipping costs proved to be the weak link in Hawai'i's beer brewing once again.

Back in Hawai'i, not everyone was happy with the territory's new brewery. A contributor to a local almanac said the brewery was fueling a growth in the number of unwanted taverns in Honolulu. "The advent of the local

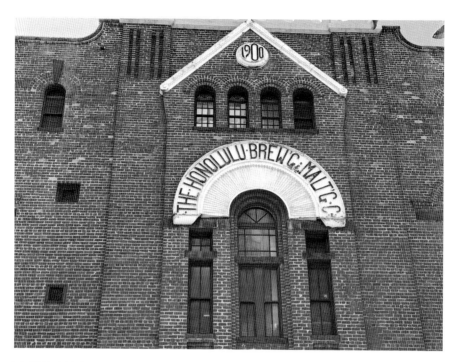

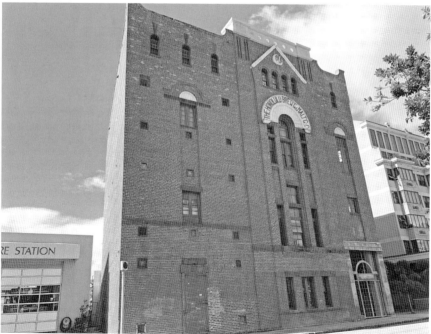

This page: Honolulu Brewing and Malting Company. *Photograph by the author.*

EVENING BULLETIN, HONOLULU, T. H. SATURDAY, MAR. 9, 1912.

PRIMO PALE

Is as scientifically brewed as any beer in the world

Your loyalty must be back of it

HARTWIG HARDERS
Brewer of Primo Pale

Hartwig Harders and Primo. *Evening Gazette*, March 9, 1912. *Courtesy of Allan Spitzer.*

brewery has been the signal for the opening up of these licensed blots on society in various parts of the city, even to the invasion of hitherto quiet neighborhoods."[71] These misgivings did little to prevent Hocking from hiring expert brewers to improve on the Primo brand.

One of those pivotal brewers was Hartwig Harders. In 1912, Hocking lured Harders, a German immigrant, away from Pabst Brewing in Wisconsin, where he patented a beer pasteurization machine and a bottle labeling system.[72] Hocking was paying Harders top dollar for his skills; he was "drawing a salary that would make you gasp—because he knows his business."[73] Harders definitely knew his business. In his new position as chief brewer at Honolulu Brewing and Malting Company, he improved brewing operations, upgraded the recipe for Primo and launched a new brand called Salvator.[74] The new brand was noted for its authentic German ingredients, but Salvator did not have the staying power of Primo, which became the most iconic and enduring beer of Hawai'i. Overall, Primo was marketed as the beer best suited for Hawai'i's climate, and it was advertised that its drinkers were supporting a "home industry."[75] Even in its earliest days, makers of Primo wanted it to be seen as "local." The advertising campaigns around Harders's improved Primo also emphasized its health

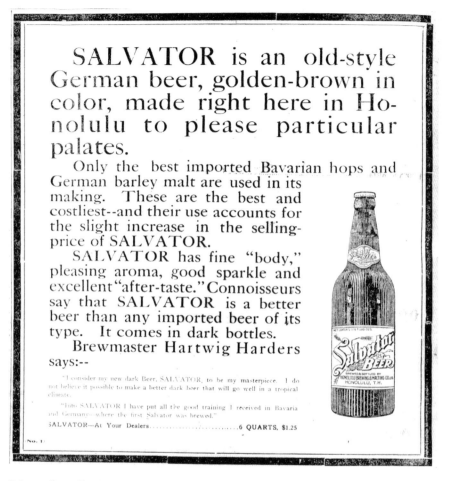

Salvator Beer. *Honolulu Advertiser*, March 21, 1915. *Courtesy of Allan Spitzer.*

benefits—although one advertisement suggested drinking it with a cheese sandwich and a cigarette for an ideal "businessman's lunch."

But a few years later, in a blow to lunchtime in Honolulu, businessmen had to eat cheese sandwiches and smoke cigarettes without a Primo chaser. In 1918, Prohibition was instituted in Hawai'i, a year and half before the Eighteenth Amendment became effective across the rest of the United States. Beer brewing became trapped in the whirlpool of American politics and foreign affairs. Prohibition, for Hawai'i, was couched as a measure to save grain for the war effort; it was said that the grain being used for producing a luxury like liquor could be used to make necessities like bread or industrial alcohol for America's war effort in Europe. It was President Woodrow

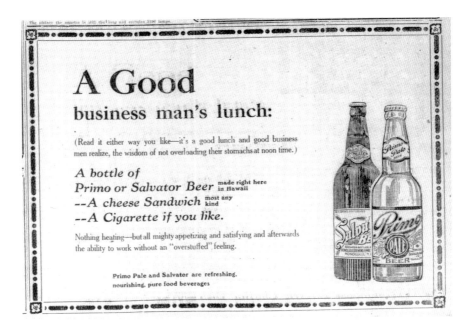

A Good
business man's lunch:

(Read it either way you like—it's a good lunch and good business men realize, the wisdom of not overloading their stomachs at noon time.)

A bottle of
Primo or Salvator Beer made right here in Hawaii
--A cheese Sandwich most any kind
--A Cigarette if you like.

Nothing heating—but all mighty appetizing and satisfying and afterwards the ability to work without an "overstuffed" feeling.

Primo Pale and Salvator are refreshing. nourishing, pure food beverages

Brewed to Suit the Climate

Primo Pale Beer is not only a fine beer, brewed by one of the best known brewmasters in the United States—our Mr Hartwig Harders—but is brewed specially for this climate.

It contains absolutely no preservative of any kind.

By drinking Primo Pale you not only drink the best beer but also patronize home industry.

Let your next order for bottled beer be PRIMO.
Sold by all dealers.

Above: An advertisement for Primo and Salvator Beers. *Honolulu Advertiser*, August 27, 1916. *Courtesy of Allan Spitzer.*

Left: An advertisement for Primo Pale. *Courtesy of the* Honolulu Advertiser, *November 1, 1912.*

The headstone of
Hartwig Harders in the
Oahu Cemetery. *Courtesy
of Allan Spitzer.*

Wilson who had already restricted the amount of grain that could be used to
brew beer the year prior. After all, there was no strategic benefit to shipping
limited grain to an isolated archipelago, far removed from the battlefields of
Europe. Prohibition in Hawai'i was a triumph for the Anti-Saloon League
in the territory, which astutely coopted the war to push for the complete
abolition of alcohol in the Islands. Under the guise of patriotism, the group
pitched Prohibition as "Americanism vs. Kaiserism."[76] Nonetheless, many
residents in Hawai'i opposed the push for Prohibition. The Honolulu Elks
Lodge tried to work out an effective compromise that would have excluded
beer from the types of banned alcohol.[77]

The efforts to fend off or compromise with Prohibition failed. Prince
Jonah Kuhio Kalaniana'ole, in his role as Hawai'i's elected representative to
the U.S Congress, believed in "home rule" for the territory and initially stood
against the federal push for Prohibition. He eventually changed his mind as
the public fervor of America's fighting in World War I gained momentum.
All alcohol was prohibited across the Islands.

O Ka Aina (Of the Land)

With alcohol banned in the territory, Honolulu Brewing and Malting Company became a part of Hawai'i's brewing history when it was forced to close its doors. Hartwig Harders and his family remained in Hawai'i. Sadly, he would never brew again; he passed away only two months before beer brewing restarted in the territory at the end of Prohibition.

PRIMO'S LONG-LOST SISTER, PRIMA

Alfred Hocking can be described with a number of words. *Prolific* is definitely one of those words. As an agriculturalist, businessman, politician and brewer, Hocking did not like to sit still. After setting up the Honolulu Brewing and Malting Company and rolling out Primo Beer, he set his sights on Asia to open another brewery.

In 1905, Hocking began scouting locations. He sent Louis Schweitzer, the secretary of Honolulu Brewing and Malting Company to explore opportunities in China and the Philippines. The choice location for the new brewery seemed to be a toss-up between Manila and Shanghai. However, the Philippines already had San Miguel Brewing, which was not thrilled with the prospect of a competitor opening nearby. San Miguel's directors strenuously objected, citing a Spanish law that granted it the monopoly on beer brewing in the Philippines. However, Schweitzer claimed that the attorney general of the Philippines had told him there was nothing "to prevent a competitor from entering the field."[78]

Perhaps not spoiling for a fight in Manila, Schweitzer was left with Shanghai as his other option. For Schweitzer, Shanghai "was the Paris of the Far East, and everything [was] on the move. There [was] business everywhere." But, for unknown reasons, Hocking chose the British colony of Hong Kong. Perhaps because he was British born, Hocking was drawn to the far-flung outpost of the empire. He opened Oriental Brewing in 1908. One of the beers it sold was "Prima," and its advertising pitch echoed that of Primo's: "The beer that's brewed to suit the climate."[79] In just a few years, Hocking had become the father of two beer brands in the history of the early–twentieth century Pacific Rim.

"DON'T SAY BEER. SAY PRIMO."

Prohibition in the Islands didn't eliminate all beer brewing. Like other parts of the United States, individual beer makers filled the gaps and brewed underground. Speakeasies spread around Hawai'i; rice replaced barley in most beer recipes. Within the territory's police department, a task force comprised of special agents was created to combat the liquor trade. Based on the large quantities of beer that this Prohibition-version of "Hawaii 5-0" often found and destroyed, the Islands' beer drinkers were still getting their suds.[80]

Just before the official end of Prohibition, beer earned a reprieve. As the Great Depression began to drain the federal treasury, President Franklin Roosevelt signed the Cullen-Harrison Act in March 1933, allowing for the manufacture and sale of 3.2 percent beer (3.2 percent alcohol by weight, but 4 percent alcohol by volume), as well as the taxation of it. Beer distributors and warehouses quickly stocked up on bottled beer from outside the Islands.

Not only did American beer shipments to Hawai'i resume, but cases of beer began arriving from Japan again. It was back in 1895, when Hawaii was a republic, that the first beers manufactured in Japan arrived in the Islands. Interestingly, the beers were heavy, black beers, like those brewed in Munich and in parts of Sweden.[81] Even with Hawai'i's growing Japanese population, the beers failed to gain much traction. Heavy beers didn't keep well in Hawai'i's climate, and local beer drinkers preferred lighter lagers. In the intervening years, Japanese breweries diversified their beer styles into lighter offerings. In 1933, T. Sumida and Co. was soon carrying ten different types of beers from eight different Japanese brands: Union, Union Black, Yebtsu, Sakura, Kabuto, Ax Brand, Sapporo and Cascade.[82] The first cases of Japan's famous Kirin Beer began arriving in Honolulu a few days later.[83] And arriving from the Philippines the following year was San Miguel Beer, which became one of the Islands' favorites well into statehood.

Local beer brewing restarted in the months following the resumption of beer shipments. The American Brewing Company was organized in May 1933 and began brewing in the same month and year that Prohibition officially ended—December 1933. The new brewery took over Honolulu Brewing and Malting Company's eighty-foot building on Queen Street and produced the first beers in Hawai'i after Prohibition.

Rather than making Primo, the American Brewing Company released Pale Ambrew (a contraction of "American Brewing") in April 1934. Like Primo's old advertisements, the advertising for Pale Ambrew touted its

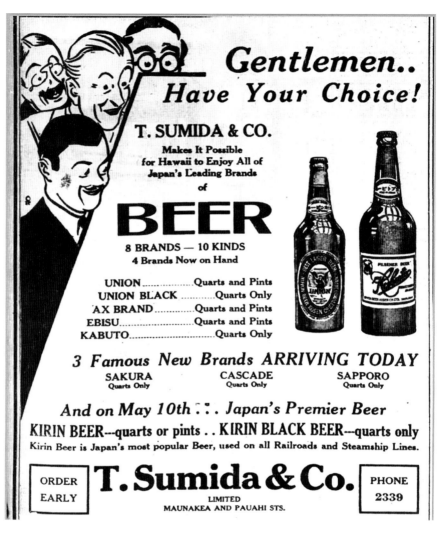

An advertisement for Japanese beers. *Courtesy of the* Honolulu Advertiser, *May 4, 1933.*

health benefits. The beer failed to gain much traction, however, and the company discontinued the brand and hired a German brewer named Walter Glockner, who developed Royal brand beer in 1937. Royal had the distinction of being the first pilsner beer brewed in Hawai'i. It became so popular that locals often referred to the Honolulu Brewing and Malting Company building as "the Royal Brewery." However, challenging Royal for dominance in the local beer market was the return of an old favorite of the Islands—Primo.

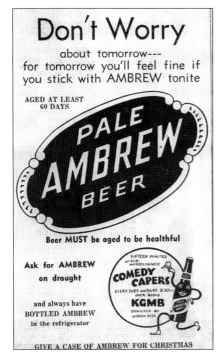 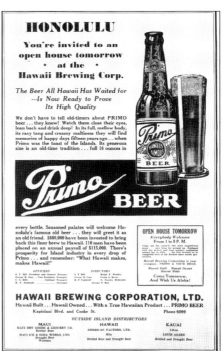

Left: An advertisement for Pale Ambrew from American Brewing. *Courtesy of the* Honolulu Advertiser, *April 23, 1934.*

Right: An advertisement for Post-Prohibition Primo Beer. *Courtesy of the* Honolulu Advertiser, *May 4, 1934.*

Primo resurfaced less than a month after Pale Ambrew hit the saloons and grocery stores around Honolulu. The competition between the two beers began almost immediately. In May 1934, Hawaii Brewing Corporation Ltd. started making a new version of Primo in a newly constructed $300,000 brewery on Kapiolani Boulevard and Cooke Street. The brewery was lauded as the first built west of the Rockies since Prohibition.[84] The caps on its bottles proudly displayed the beer's new slogan, "Don't Say Beer. Say Primo."[85]

But as the competition between Primo and Royal heated up, labor unrest gripped both breweries. Beer brewing was swept up in the growing labor movement that was happening around the Islands and across America. Brewery workers unionized to demand their rights. A fifty-day strike in late 1938 at the Hawaii Brewing Corporation's brewery frustrated anyone who wanted a cold Primo, especially when the strike spread to include sympathetic

downtown Honolulu bartenders who refused to serve Primo and ice factory workers who declined to cross picket lines.[86] Meanwhile, the strike at the brewery of the American Brewing Company, although short-lived, still left open wounds in its aftermath. As part of the settlement with union leaders, the brewery owners agreed to fire fourteen workers who were kicked out of the union for not participating in the strike. However, the brewery's manager refused to carry out the owners' decision and resigned.[87] The legacies of both strikes were better wages and closed shops—there were only union breweries in Honolulu.[88]

As soon as brewing regained its footing after the brewery strikes, Hawai'i's beer industry was nearly wiped out by another world war. Prohibition returned to the Islands after the attack on Pearl Harbor in December 1941. From the day of the attacks until February 1942, the military governor of Hawai'i banned the sale of alcohol. After the ban was lifted, alcohol sales were heavily restricted, and beer shipments from the Mainland were sporadic. Hawaii Brewing and American Brewing struggled to maintain their beers' prewar quality in the face of infrequent arrivals of key ingredients, such as grain and hops. In addition to difficulty in getting ingredients, the wartime paranoia in Hawai'i hit American Brewing Company in an unexpected way. Walter Glockner, Royal's chief brewer, and several other German-born naturalized U.S. citizens in Hawai'i were interned along with Japanese Americans as a wartime measure. Glockner and the other German-born men eventually won their release in court; Glockner decided to move to Stevens Point Beverage in Wisconsin for the duration of World War II. After the war, however, he made his way back to the American Brewing Company. He regained his former position and took up where he left off, making Royal beer.

One side effect of World War II was the creation of an image of Hawai'i being both American and exotic at the same time. U.S. military personnel on their way to and from the war in the Pacific regularly stopped in Hawai'i for shore leave. Drinking local beer was associated with patriotism and adventure. Helping cement the image of the Hawai'i as America's tropical paradise were the depictions of beaches and hula girls in the media images of the day. A vibrant tourism industry emerged in the postwar years; it's an industry that is now the anchor of Hawai'i's economy.

Beer brewing would find more challenges and triumphs when Hawai'i became a state in 1959. The change in Hawai'i's political life was also matched by changes in technology and economics, creating a more vibrant beer culture in the Islands that continues to this day.

3.

STATEHOOD BREWING

A year before Hawai'i became the fiftieth state, the brewers of Primo introduced what became a revolution in the beer industry. As a way to cut down on their shipping costs while trying to widen their market share, the brewers of Primo released it in the eleven-ounce "Shiny Steiny," the first aluminum can for beer. The parts for the aluminum can weighed less than the materials necessary for tinplate cans, making every case of beer three pounds lighter.[89] This sharply reduced transportation costs. However, the brewing company had rushed the Shiny Steiny to market too quickly, and the aluminum can failed to deliver quality beer. Mistakes in design gave the beer a metallic flavor and, when the can was opened, it often resulted in showering the drinker with beer. These mistakes were not only messy, but they were also costly. In a move that would make any beer lover cry, Hawaii Brewing Company decided to destroy the defective cases of Primo—all thirty-three thousand of them, or more than one can of beer per person living in Hawai'i at the time.[90] Eventually, the brewery stopped using the Shiny Steiny. However, the aluminum can was a brewing milestone and one of the major legacies that Hawai'i left to the global beer industry.

The beer industry in Hawai'i was growing as statehood approached. Vast improvements in transportation, like containerization, gave an additional boost to Hawai'i's beer drinkers. The delivery of brewing ingredients was reliable, and ingredients could be shipped in larger quantities than ever before. Modern transportation allowed local breweries to consistently produce more beer for locals, tourists and members of the military while boosting the economic fortunes of the Islands.

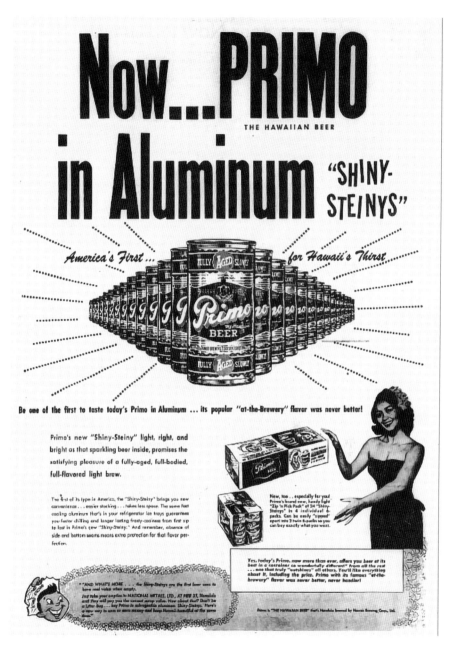

An advertisement for the "Shiny Steiny," the first beer in an aluminum can. *Courtesy of the* Hawaii Star-Bulletin, *April 19, 1959.*

Left: An advertisement for Royal Beer, 1958. *Photograph by the author.*

Right: Kimo Primo, the cartoon character for Primo. *Courtesy of the* Honolulu Advertiser, *1958.*

Hawai'i's achievement of statehood in August 1959 provided it with almost immediate and unprecedented economic growth. Three days after Hawai'i became a state, Pan Am Airlines started the first commercial jet service to Honolulu. This convenience opened Hawai'i to middle-class tourists, not just the wealthier travelers of previous decades who could afford the voyage by ship. Increased tourism also spawned new construction and light industry to support the building of freeways and hotels. This, in turn, created a new middle class in the Islands, who looked forward to taking time off from work while drinking a cold beer.

For Hawai'i, statehood meant there were more beer drinkers to satisfy, but the two local brewing companies faced competition from larger Mainland brewing corporations. Hawai'i's location continued to present challenges for Hawai'i's brewers; shipping and production costs remained high. Budweiser and Miller were able to use their financial power to deliver greater quantities of their beer to an underexplored and expanding market

in a new state, giving beer drinkers more choices while also undercutting local breweries.

In such a competitive beer market, Royal and Primo continued to slug it out through statehood. American Brewing Company and its Royal beer struggled even after a new Mainland brewer was brought to Hawai'i, bringing a $250,000 modernization of the brewery and the distribution of two new beers.[91] It wasn't enough. American Brewing Company shut down in 1962, ending the run for Royal.

Although Primo emerged as the winner of their rivalry, it was a hollow victory for Primo's parent company. Hawaii Brewing Company could not maintain its independence in the face of the challenge from a Mainland brewing powerhouse. In 1964, the Schlitz Brewing Company purchased Hawaii Brewing Company and moved Primo's brewing to a new $5 million plant in Pearl City. This large investment in a new brewing plant coincided with the continuing economic growth in the Islands, most notably in the state's tourism sector. As *Time* magazine reported in 1966:

> *Already, tourists spend $300 million a year, making tourism Hawaii's largest civilian source of income, larger than the pineapple and sugar businesses combined. To accommodate them, some $350 million worth of hotel construction has gone up in the past five years. The boom has also created new jobs to absorb the unemployment created by automation on the plantations.*[92]

As the only beer produced in a booming state, Primo came to dominate the local beer sales, capturing an astonishing 70 percent of the market in 1969. Much like its early days, the brand was consciously marketed as part of Hawai'i. The artwork on its label—the silhouetted profile of King Kamehameha I—came to be an iconic part of Hawaiian popular culture and was featured on almost everything, from Hawaiian shirts and swim trunks to beach towels. Primo also sponsored sports competitions, like surfing, to promote its image as part of the local Hawaiian lifestyle.

However, Primo began to lose its competitive edge in the 1970s. Schlitz's technique of creating the beer's wort in its Los Angeles brewery, evaporating it for shipment to Hawai'i and then having the brewery in Honolulu reconstitute it with Hawaiian water made Primo's flavor no different (or worse) than Mainland beers that were often sold at the same or cheaper price. By 1974, Primo's market share plummeted dramatically to slightly over 19 percent—well behind the Mainland brands of Budweiser and

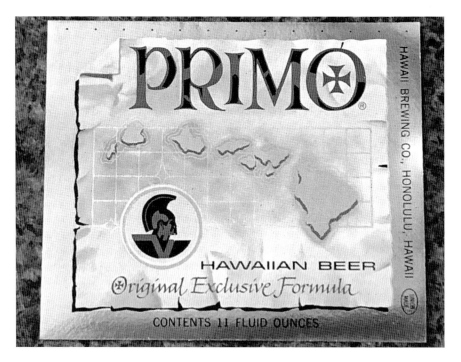

Primo Beer label. *Photograph by the author.*

Olympia.[93] Coors also entered the market by offering good-tasting, cheaply priced canned beer; it was the only beer that was consistently refrigerated from production all the way through shipping to Hawai'i's stores. Adding to Primo's woes was the "green bottle" phenomenon—imported beers like Steinlager from New Zealand and Heineken from Holland created a market for premium beers with a better taste for a fraction more than Primo's price.

Primo would not recover its dominance. Not only had its flavor lost appeal, but it had also lost something more important—its "localness." Even as Schlitz's switched to milling grain and creating wort at an upgraded brewery, it failed to convince locals that Primo was still part of Hawai'i. People's skepticism was borne out when the last cases of locally made Primo came off the brewery loading docks in May 1979; all of Primo's production was moved to Schlitz's Los Angeles brewery. Large-scale beer brewing had officially ended in Hawai'i. Three years later, Stroh's Brewing Company purchased Schlitz and relaunched the Primo brand, but it continued to brew it on the Mainland.

Selling a Hawaiian beer that was made on the Mainland was ironic—and ultimately unsuccessful. Brewing a "Hawaiian" beer on the Mainland was

more cost-efficient, and Stroh's expanded Primo's distribution across the United States and to Japan. Primo was Hawai'i's beer ambassador—that wasn't made in Hawai'i. In another ironic twist, the new generation of beer drinkers on the Islands had moved on from Primo and adopted Mainland and imported beers as their own. Many people in Hawai'i resisted viewing the brand as local anymore. Stroh's tried to compensate by putting Primo in green, long-neck bottles; this was also done to compete with premium bottled beers and blend in with the green bottle phenomenon in the Islands. The tactic fell flat, as people in Hawai'i viewed it as a hollow attempt by a cheap Mainland beer to pass itself off as both local and premium. For younger beer drinkers, Primo was seen as both inauthentic and old-fashioned rather than authentic and "old-school."

One final ironic twist foreshadowed the end to Primo. It was the repeal of a law left over from Prohibition, the era that had ended the brand's initial run when the Honolulu Brewing and Malting Company was manufacturing it. In 1978, President Jimmy Carter signed a bill that made it legal for people to brew beer at home. With a stroke of his pen, Carter deregulated the federal control of beer production that had shut out smaller brewers from competing with the brewing giants. Microbrewing emerged, and the wave reached Hawai'i, helping swamp Primo. In 1998, in the face of rising locally made microbrews, along with the brand's inability to reclaim the local market from Mainland and imported beers, Stroh's stopped making what was once nicknamed "Hawaiian Champagne." Primo's end came one hundred years after its original parent brewery was founded. For the twentieth century, Primo was *pau* (done).

LOCAL BREWING RETURNS

The early days of microbrewing first took off in a region of the Mainland that had once influenced the history and economy of Hawai'i when it was a kingdom. On the West Coast, smaller breweries began to sprout, but many did not have the production capacity for widespread distribution to other parts of the country, including Hawai'i. However, many Hawaiian locals had spent time on the West Coast while, at the same time, microbrewing popped up across the United States, and many people from the Mainland had either moved to Hawai'i or were stationed in the state as part of their military service. As a result, an increasing number of people in Hawai'i had

encountered and drunk more flavorful, smaller-batch beers during their Mainland experiences, and they brought their tastes with them to Hawai'i.

The first wave of small-batch brewing faced a number of strong cross currents. Finding the financial capital to launch a brewpub was difficult; banks were skeptical of loaning money to a brewery they felt couldn't stand up to the large-scale corporate brewers, let alone break the local demand for well-known, name-brand beers. With limited resources to market their beer, combined with laws that restricted canning and bottling as well as distribution, led to many of Hawai'i's initial microbreweries being Mainland chains, small pubs or adjuncts of restaurants.

The first microbrew in Hawai'i was produced in Wailuku, Maui, by Pacific Brewing Company in 1985; it was also the first beer to be made in Hawai'i since Schlitz's stopped the local brewing of Primo in 1979. Owned by German-born Klaus Haberich and Aloysius Klink, along with their fellow countryman Gunter Dittrich as the chief brewer, Pacific Brewing Company created the popular Maui Lager. In addition to the German owners and brewer, the brewery itself was truly international, with equipment from Germany, Austria and Britain and bottles from New Zealand.[94] Pacific Brewing Company wasn't alone in the Islands for long; Honolulu Brewing Company was established in Kalihi and began making Koolau Lager in 1986, with Pali Hawaiian Beer and Diamond Head Dry soon following. Sadly, these first microbreweries barely made it into the beginning of the 1990s before going bankrupt. But by 1995, one survey counted five microbreweries, seven brewpubs and a contract brewer operating in the state.[95]

Many of the initial microbreweries in Hawai'i during the 1980s, 1990s and early 2000s closed just as quickly as the breweries in early Hawaiian history. Only a few of these first microbreweries have survived and evolved. Although more people in Hawai'i had been exposed to different beers, the majority of people in the state still preferred lighter beers, like Miller and Budweiser, as they were cheaper than microbrew beers; others preferred Heineken, as it was seen as a premium beer. Convincing those beer drinkers to put down their lighter lagers and venture out to try hoppier and maltier beers was a challenge.[96] Also, the same issues that had plagued the early brewers in Hawai'i's history remained—the logistics of shipping ingredients and equipment. Although ingredients and equipment could be shipped reliably, the small quantities that microbreweries needed were more expensive because they were not purchased and shipped in bulk. The result was that many microbreweries in Hawai'i were producing inconsistent batches of beer with varied quality and unpredictable brewing output.[97]

Microbrewing soon gave way to craft brewing, which has taken more of a solid hold in Hawai'i. The contemporary craft brewing movement in the state has been boosted by the newfound appreciation for locally made goods. The state and county governments, in conjunction with the business community, began campaigns aimed at getting consumers to buy locally grown produce and support local businesses. These campaigns to "buy local" and buy goods "made in Hawaii" created more awareness to consciously purchase what was produced locally, including beer. Tourists visiting the Islands now also want to have unique beers that they can't get back where they live. This has made beers from large-scale breweries comparatively unappealing to many tourists. It's not as much fun to travel all the way to a tropical wonderland and then just have a Bud Light.

Even Primo staged a type of comeback by hopping on the craft beer bandwagon. In 2007, hoping to piggyback on the growing craft beer movement, Pabst Brewing Company introduced Primo with a new formula, saying it had "a distinct rich taste of craft-brewed beer with the smoothness and drinkability of lighter lager" and "a touch of Hawaiian cane sugar grown on Maui." Pabst had acquired the brand from Stroh's in 1999. It was one more twist in the ever-winding history of Primo. After all, it was from Pabst that Hartwig Harders was hired to reinvent Primo in Hawai'i in 1912. But the brewing company he left had absorbed the brand he had helped make a fixture in the life of Hawai'i. The newly branded "Primo Island Lager" was initially a hybrid rather than a true craft beer; the draft version was brewed in the Islands at Keoki Brewing Company in Kauai, but Pabst agreed to use Miller Brewing Company's brewery in California to produce the bottled version. After several years, the local production of Primo ceased, and it is now, as it was at the end of the twentieth century, brewed entirely on the Mainland.

A Brewing Community

Hawaiian breweries today are just as economically mighty, if not more so, than their brewing ancestors. Once, there were just one or two large-scale industrial breweries located in Honolulu, but today, more than twenty small-scale breweries located across the island chain contribute $291 million to the state's economy.[98] Much like other small businesses, money that is spent on beers from local breweries tends to stay in the community

more than money spent on beers from major commercial breweries. Plus, the increase in the number of local craft breweries often contributes to an area's economic development.

Although locally focused, many of Hawai'i's craft brewers want to share their products in other beer markets on the Mainland. With the exceptions of Kona Brewing and Maui Brewing, most of the state's beers are largely unknown outside of the Islands. Once again, the costs associated with transportation are the major constraints. "It's crazy," the sales director at Honolulu Beerworks, Sharon Heitzenroder, exclaims. "You have to get the beer to port, get it in a refrigerated cargo container, pay for the container, pay for the freight fee to get it shipped overseas, and then pay for another docking fee to get it to another port. Then you pay another transfer fee to get it onto another truck, and then back to another distributor warehouse."[99]

But the craziness that constrains the ability to distribute beer to the Mainland market have only made the state's craft brewers more determined to make great beer for the Islands. Instead of creating rivalries, a brewing community has arisen from the sheer number of breweries that are now operating in the state. As the chief brewmaster at the Waikiki Brewing Company put it, "It's a friendly camaraderie here among brewers. A rising tide lifts all boats."[100] This determination has meant that Hawaiian craft breweries have joined together to reduce the challenges associated with shipping supplies to Hawai'i. Breweries routinely cooperate with each other. If one brewery has a grain shipment delayed or has a wrong order shipped, another brewery may step in to offer its surplus grain. The same goes for brewing parts. A brewery might have a spare part for another brewery whose production will suffer because it has to wait for the part to be delivered from outside the state. Often, breweries will routinely combine orders to reduce shipping costs as well.

Brewers have also banded together to push for changes to outdated laws that curtail distribution. Just a few years ago, only a few craft brewers could attempt to influence the state legislature on their own. Garrett Marrero, the founder and owner of Maui Brewing Company, described those early days: "I did feel like I walked those halls alone for so long."[101] But now, "other brewers show up to testify arm-in-arm. We filled up an elevator!" Permitting brewpubs and taprooms in breweries to sell their beer directly to customers in kegs, bottles, cans and growlers to-go required a change to the law. Another important legal change permitted craft brewers to sell their beers directly to other establishments without having to use a licensed middleman like a distributor.

Changing parts of the liquor code has helped today's craft breweries in Hawai'i keep pace with contemporary trends. Other changes to the liquor code have made taprooms more accessible to families and have made it easier to serve flights of beer to customers. Unlike the industrial breweries of Hawai'i's past, contemporary craft breweries are places where people want to go and hang out. The state's breweries aren't just places with mash tuns, boil kettles, fermentation tanks and canning equipment; they are places where people can drink a beer and pair it with locally sourced food. Many craft breweries use their beers in recipes for their dishes as well. The taprooms are open-air or have lanais to invite the beauty of the Islands to be part of beer drinking. The experience

The Inu Island Ales and Village Bottle Shop collaboration beer. *Courtesy of Village Bottle Shop.*

is a long way from the days of going to a downtown Honolulu saloon at lunchtime for a Primo, cheese sandwich and cigarette.

Experiencing local Hawaiian beers has also become part of the social fabric of the Islands. While breweries of yesteryear often supported local events, breweries today sponsor their own joint events and are active participants in others. Hawai'i's calendar is now dotted with craft brew festivals or events, like Hawaii Craft Beer Festival, Beers on the Pier and Waikiki Beer Festival, where craft breweries set up their tents and share their brews.

These beer events showcase not only the variety of brewers, but also the increasing variety of beers. The state's craft beers share little in common with the large commercial breweries of the past. Beers today are more than just ales, lagers, steam beers and pilsners. Craft brews are infused with local ingredients and fermented with wild yeast strains that the brewers during the days of the Kingdom of Hawaii and the Territory of Hawaii could not have imagined. Hawai'i's craft brewers are using the diversity of the Islands' natural bounty to create unique brews that surpass the flavor of the large-scale commercial beers of yesteryear. While respecting the past is important, nostalgia is one ingredient that Hawai'i's craft brewers do not rely on.

Stewbum and Stonewall goes surfing. *Courtesy of Stewbum and Stonewall.*

There is only a faint nostalgia for the beers of Hawai'i's past—similar to the way hipsters on the Mainland crave the "authenticity" of a mass-produced PBR or Natty Boh. The current brewers of Primo have gone back to the beer's original recipe from the early twentieth century, and they rely on the label's artwork from the late twentieth century. All the nods to Primo's history haven't created a wave of enthusiasm among the Islands' beer drinkers, especially amidst all of the innovative craft brews that are currently on the market. The only corporate beer that comes close to provoking a nostalgic feeling of authentic localness is, ironically, Heineken. In 2012, Native Hawaiian singer Bo Napoleon released "Born and Raised," with the lyrics, "One foot on sand, one hand Heineken. Hawaiian, I am." And Heineken knows how to maintain its identification with the Islands. In 2019, Heineken became the official beer of University of Hawai'i Athletics. The Dutch beer in a green bottle had become part of the green, silver, black and white of the UH Rainbow Warriors and Wahines.

The COVID-19 pandemic did deal a body blow to Hawai'i's craft brewery movement. The arrival of the coronavirus in the state forced all breweries to quickly pivot and adjust their business models—more to-go beers and help from and for the local community. Sadly, one of the real pioneers of the craft beer scene in Hawai'i, REAL Gastropub in Kaka'ako, could not survive the stay-at-home orders and did not reopen. As Joshua DeMello of www.islandbeerunion.com noted, REAL Gastropub "brought beers and serving styles commonplace elsewhere [to Hawai'i]. It made REAL a legit

beer place for beer geeks."[102] From its parking lot, the owners of REAL started the first beer festival on Oahu, the Honolulu Brewers Festival.

But there have been triumphs amid the pandemic as well; a new craft brewery, Broken Boundary Brewery, began making and serving beer in the early stages of the state's lockdown. Several other breweries banded together to make beers to support unemployed hospitality industry workers. Beer brewing in Hawai'i cannot be held down and will continue to rise.

From sovereign kingdom to U.S. state, it's been a long voyage for brewing in Hawai'i. Without a doubt, the voyage has been choppy, as many adventures are. As seen in the history of Hawai'i's brewing, the story of the *aina* may have changed, but the challenges it has presented have made the appreciation for it grow stronger as the years have rolled on. And the voyage continues in the view of Tom Kearns from the Big Island Brewhaus: "People are discovering beer isn't just the mass-market stuff, but it's also many other types of beer. Over the course of weeks, months and years, it adds up to a societal sort of change. People are still discovering what brewing can be and how it fits into their life, you know?"[103] Creating another beer mecca like Seattle, Portland, Denver and San Diego in the very heart of the Pacific is still an attainable goal, even in the face of a global pandemic. The adventurous brewers of yesteryear led the way for the current success of craft brewers in the Fiftieth State.

With Hawai'i's brewing adventures, past and present, firmly in mind, it's time to go *holoholo* around the Islands to see where and what local creations the new adventurers are brewing.

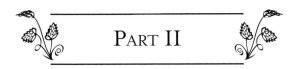

PART II

Holoholo

(To Leisurely Roam)

4.

"On the Islands,
We Do It Island Style"
The Many Brewing Cultures of the Islands

Thanks to all the brewers of Hawai'i's past, there are now more breweries in the Islands than there have been at any other point in history. The handcrafted beers of Hawai'i share similar characteristics around the Islands. Because brewing is an expensive endeavor that is made more capital intensive with Hawai'i's high cost of living, breweries and their taprooms in the state are usually found in older buildings and often use reclaimed materials for construction. Hawaiian craft breweries also seek to be sustainable, with several of them using photovoltaic solar panels to reduce their carbon footprints. Many of the breweries have the goal of being completely off the grid in the near future. The breweries emphasize their local roots and have local antiques or local artwork placed around their taprooms as a way to appeal to beer drinkers who want to avoid larger commercially made corporate beer. The names of these beers often refer to legends, lore and locations and are sprinkled with Hawaiian or Pidgin words.

These shared characteristics, however, do not mean that all of Hawai'i's beers are the same or can be found all around the Islands. Local beer in Hawai'i isn't just a beer made in the state; the term *local* can refer to a beer made on any particular island. Tim Golden, the owner of Village Bottle Shop and Tasting Room in Honolulu, compares the phenomenon to supporting a local sports team: "Similar to if you're in New York, you're either a Jets or a Giants fan, right? I think, with local breweries, there's that same sort of feeling, and people like to go *pau hana* at one versus another, but people like to jump to all of them, right?"[104] In many ways, this is due to the

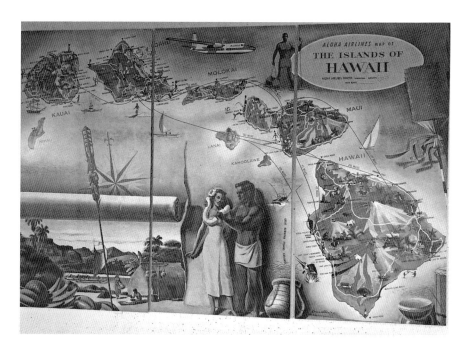

A mural of the Hawaiian Islands at Honolulu International Airport. *Photograph by the author.*

state's geography. Beers brewed on different islands, much like Mainland or imported beers, still have to deal with shipping logistics. Without a road network linking the state together, inter-island beer distribution is sporadic in Hawai'i. Not every brewery has developed the resources to can, bottle and distribute their beers for sale throughout the Islands. Nor do all of the breweries aim for greater packaged distribution. Kegged beer in restaurants or bars has compensated for the lack of a craft brewery's six-packs on the shelves of a nearby store. But, for many craft beer drinkers in the state, a visit to a local craft brewery's taproom is the best way to experience how an island's culture is expressed.

As the only state that is an archipelago, each island has its own unique history, pattern of life and "vibe." On the Mainland, cities, counties or parts of a state often differ from one another. In many ways, Hawai'i is similar. Just like San Francisco differs from Los Angeles and Tampa Bay is different from Miami, Maui is unlike Kauai. Each island has its own style that reflects its connection to the *aina*.

Knowing how each island differs from the others offers a key insight to each of the islands' individual brewing styles.

Holoholo (To Leisurely Roam)

OAHU: THE GATHERING PLACE OF BREWERS

It's fitting to start the exploration on Oahu where the brewer of the first king of Hawai'i made a barrel of what would now be considered craft beer. Home to the state's capital, the urban center of Honolulu, the hub of the U.S military presence in the Pacific and the world-famous Waikiki, the island of Oahu is a vibrant and eclectic place. Being the center of commerce, politics and tourism makes the island a fertile place for craft brewing to take root. It's no surprise that Oahu is the island with the most breweries in the state.

The centrality of Oahu and its position as a crossroads of the Pacific has made it a magnet for larger craft breweries. One of the larger brewpub chains in the United States, Gordon Biersch, opened in 1994 in the Aloha Tower Marketplace. Larger Hawaiian breweries, like Kona Brewing Company and Maui Brewing Company, have also opened franchise brewpubs around the island. However, beers from Honolulu breweries have yet to spread to the other islands in the same way. It's an unusual turn; beers of Hawai'i's past were brewed in Honolulu and then sent to satisfy beer drinkers on the different islands.

But, in keeping with the brewing tradition of Hawai'i's past, the Kaka'ako neighborhood of Honolulu is central to Oahu's beer making renaissance. In the shadow of Honolulu Brewing and Malting Company's still-standing eighty-foot brewery and with the echoes of kegs of Primo coming off the production line at the long-gone American Brewing Company, Kaka'ako is alive again with the sounds and smells of beer making. What was once an area of light industry and office buildings has been redeveloped and gentrified with condos and restaurants, as well as craft breweries and their taprooms.

Oahu's brewing has not been confined to Kaka'ako. There are craft breweries in other parts of Honolulu, and they have sprung up on the Windward side as well. In the Pearl City area, which once provided the home to the brewery that made Primo until it moved to the Mainland, there are craft breweries that are experimenting with making new beers based on new science. In Kailua and Kaneohe, brewers are using their distance from the urban vibe of Honolulu to draw inspiration from the natural surroundings of the *aina*.

The island's breweries reflect Oahu's diversity—beers are brewed in the city, the country, the suburbs and close to the beach. They are made with locals and visitors in mind. The craft beer options are growing on Oahu, making the island a vital and vibrant place for beer lovers once again.

Hele on to Kauai for Some Great Beer

Kauai has a laid-back and proudly independent vibe, reflecting its distinct history. Kauai is geologically the oldest island, and it is the longest continually inhabited island. Along with its neighboring island of Ni'ihau, Kauai is the only island that King Kamehameha I did not conquer by force in his desire to build a kingdom. Kauai was also the destination of Captain John Tyler, the drinking buddy of the Kingdom of Hawai'i's first brewer, Manini. Captain Tyler was part of Russian American Company's effort to regain the goods it lost in a shipwreck off the coast of Kauai. The ruler of Kauai, in a failed attempt to gain his island's lost independence from the sovereignty of King Kamehameha I, sought to bargain with the Russians for help. The ruins of the Russian-constructed Fort Elizabeth on Kauai's south side stand as a testament to this failed plot.

Part of Kauai's modern independent streak is its residents' desire to keep the island's *aina* as pristine as possible. To prevent the potential for overdevelopment on Kauai, building codes were changed after two large resorts were constructed. Now, new buildings cannot be taller than a palm tree. Both of the breweries on the island fit snugly into older buildings and highlight Kauai's unique beauty.

Today, Kauai's brewing matches its independent past and laid-back feel. In a lighthearted nod to the wild chickens freely roaming around the island, the Kauai Beer Company's logo is a rooster. Kauai Island Brewing Company's open windows on its second floor have an unmatched view of the sunset over Hanapepe Bay.

Maui *No Ka Oi*, And So Is the Beer

Much like the demi-god Maui, who was part-human and part-deity, there is a duality to the island of Maui. The island is home to mountains and valleys, upcountry and beaches, ranches and towns. As part of this duality, Maui also wrestles with finding the right balance between development and preservation. Maui has an artistic vibe that is instantly noticeable. Many artists make Maui home because they're inspired by the contrasts of the island's *aina*. They choose Maui to avoid the big city feel of the Honolulu metropolitan area. As one island resident put it, "We don't want to be Oahu."

But Maui almost became Oahu. Lahaina was the original capital of the Kingdom of Hawaii before Kamehameha I moved it to Honolulu. Whaling vessels and merchants routinely made port calls in Lahaina, just as they did in Honolulu. The island was also similarly filled with missionaries, plantation workers and ranchers. Had Lahaina remained the capital of the Kingdom of Hawai'i, it may have become like Honolulu in another way—the central site of Hawai'i's brewing history.

Maui's brewing culture hasn't been left behind. The island took the first plunge into the microbrew movement in 1985; Wailuku was the first town in the state to become home to a microbrewery. And today, Maui continues to ride the wave of Hawai'i craft beer movement, with Maui Brewing Company as the largest craft brewery in the state.

Brewing Erupts on the Big Island of Hawai'i

Coming full circle with Hawai'i's brewing tradition means ending an island-hopping exploration on the Big Island of Hawai'i. Captain James Cook made the first recorded beer in the Islands just off Hawai'i's coast, and that marked the opening of the Islands to the rest of the world. This was also the island where King Kamehameha I was born and died. It is where Kona Brewing Company started in 1994 and where it went on to become one of the most recognizable Hawaiian beers around the world. Kona Brewing Company was the local beer that had "made it" when Craft Brew Alliance and its parent company, Anheuser-Busch InBev, purchased the rights to brew the beers of Kona Brewing Company in locations outside of Hawai'i.

Despite Kona Brewing Company's success in the wider world, the Big Island of Hawai'i takes pride in keeping itself "country." The Big Island is for people who want rural, uncomplicated tropical living. With large parts of the island still untouched by development and with several different climactic zones, living off the grid is a genuine option for many residents. Sustainability and care for the *aina* are key parts of the brewing ethos on the Big Island. For the Big Island Brewhaus, this commitment has led them to be certified by the Surfrider Foundation as a Platinum Level Ocean Friendly Restaurant and to be the second Blue Zone Approved restaurant on the island.

Plantations and ranching were once large staples of the island. Reflecting the influence of Japanese and Okinawan immigration during Hawai'i's

plantation era, the first breweries on the island made sake, not beer. There are still *paniolos* (cowboys) at work on the ranches scattered around the island. The island's ranching and farming roots run deep; today's beer breweries on the Big Island regularly incorporate locally grown products in their beers. Ola Brew Co. goes a step farther by encouraging and incorporating community investment in its brewery. It is not only employee owned, but it boasts over 650 small investors.

The Big Island is also the geologically youngest island in the archipelago— and it's still growing. With the active volcano of Kilauea given to periodic but sustained eruptions, lava flows have often reached the ocean. But these eruptions haven't prevented the island's brewers from making, serving and distributing their beers. That's a real devotion to brewing.

ACROSS TIME AND ACROSS THE ISLANDS

Today's brewing in Hawai'i can't be separated from its past any more than a single wave can be separated from the ocean. The past and the present are part of the same movement. But just like each wave comes ashore differently, beer brewing has arrived on the state's individual islands in distinct ways. Hawai'i's history, culture and traditions may be broadly shared across the archipelago, but beer brewing is one way in which each island's diversity shines through. Eclectic, independent, artistic and uncomplicated are all characteristics of the beers in paradise. Respecting and caring for the *aina* are revealed in different ways when visiting the craft breweries from Kauai to the Big Island.

Today, the craft breweries in Hawai'i are owned and operated by some of the most skilled, thoughtful and creative people in the world—they just so happen to love working in paradise. So, it's time to turn the page and visit the breweries that are making Hawai'i a standout in the global craft beer movement.

"Shoots, We Go!"

A List of the Islands' Breweries

The previous chapter provided a flavor of how the various cultures of the different islands have influenced their individual brewing styles. Respect for the *aina* is translated in different ways across the brewing islands of Oahu, Kauai, Maui and the Big Island. With that in mind, it's time to island hop to explore and discover the variety and special qualities of today's Hawaiian breweries and their beers.

What's the quintessential and essential Hawaiian beer, and what's the best way to experience it? The answers to these questions are as diverse as the Islands themselves. This chapter is a short guide that you use when visiting the breweries. Take this book with you to chart the course for your own answers. Below is a list of each island's breweries, a description of their uniqueness and a section for writing notes about your visit.

Okole maluna! (Cheers!)

OAHU

Aloha Beer Company

700 Queen Street
Honolulu, HI 96813
(808) 544-1605
@alohabeercokakaako

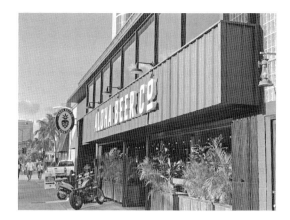

Aloha Beer Company. *Photograph by the author.*

Aloha Beer Company is located in Kaka'ako, which was home to Hawai'i's booming beer business from 1900 to the late 1960s. Aloha Beer's production facility and taproom is located a stone's throw from the historic Honolulu Brewing and Malting Company Building on Queen Street, and it is blocks away from the former site of Primo's Cooke Street brewery. It lives up to its motto: "Our beer is brewed in Hawaii for Hawaii."[105]

Beer Lab HI

Three locations:

1010 University Avenue
Honolulu, HI 96826
(808) 888-0913

94–515 Uke'e Street #310
Waipahu, HI 96797
(808) 517-3128

Uptown Center Court: Pearlridge Center 98–1005 Moanalua Road
Aiea, HI 96701
(808) 888-0913
@beerlabhi

Three local buddies from Hawai'i were working as engineers for the U.S. Navy when they decided to turn their hobby into Beer Lab HI in 2015.

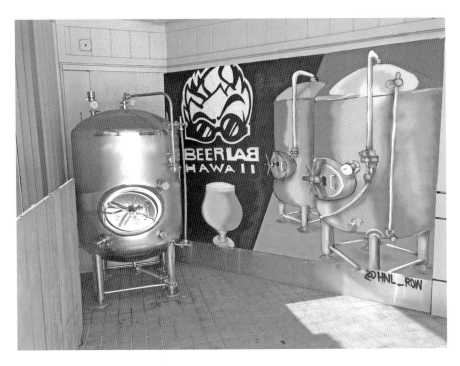

Beer Lab Hawaii, University location. *Photograph by the author.*

Their brewery is built on the concept of constant change, experimentation and small-batch brews to ensure that beer lovers have a memorable experience with every visit. They want people to "Live Pono. Drink Ono." ("Live Righteously. Drink Deliciously.") The possibilities are endless, and their welcoming spirit is felt immediately after stepping into any one of their locations.[106]

Brew'd Craft Pub

3441 Waialae Avenue Suite A
Honolulu, HI 96816
(808) 732-2337
@brewdcraftpub

Brew'd is an awesome gastropub in the heart of old Kaimuki. With a tradition started at REAL in Kaka'ako, the owners are dedicated to pairing great craft beer with delicious local cuisine.

Broken Boundary Brewery

740 Moowaa Street
Honolulu, HI 96817
(808) 834-2739
@brokenboundary808

Located in Homebrew in Paradise, Broken Boundary Brewery opened in the middle of the restrictions related to the outbreak of COVID-19. The owners defied the odds and began brewing in a pandemic. Stay-at-home restrictions and quarantines haven't stopped them from honoring authentic brewing traditions while exploring the potential of beer.

Grace in Growlers

143 Hekili Street
Kailua, HI 96734
(808) 975-9317
@graceingrowlers

This is the first and only self-serve craft beer tasting room in the state of Hawaii. At Grace in Growlers, customers can pour their own beer and pay by the ounce. With a rotating tap list of local beers, it's a "craft beer tasting room with a purpose."[107]

Hana Koa Brewing Company

962 Kawaiahao Street
Honolulu, HI 96814
@hanakoabrewing

Hana Koa Brewing Company has a thirst for adventure. The brewery's passion is exploring the world for inspiration and creating new, unexpected flavors in Hawai'i. It's always pushing the envelope of the brewing craft. The brewers want its customers to taste their passion in every pint.[108] The brewery is housed in an old Coca-Cola syrup warehouse that was converted into a storage facility for the equipment and sets of the Honolulu Opera.

Holoholo (To Leisurely Roam)

Left: Hana Koa Brewing Company. *Photograph by the author.*

Below: Honolulu Beerworks. *Photograph by the author.*

Honolulu Beerworks: "Oahu Brewed"

328 Cooke Street
Honolulu, HI 96818
(808) 589-2337
@honolulubeer

With recycled wood walls showcasing local artwork, the open-air brewpub reflects the hip, rustic charm of Kaka'ako. Communal bench seating and outdoor beer gardens create a fun and friendly ambiance. Opening in 2014, Honolulu Beerworks is a neighborhood craft brewery in the heart of Kaka'ako. From the beginning, the brewery has focused on using unique and locally sourced ingredients in the brewing process. Honolulu Beerworks now has an experimental and robust barrel aging program.[109]

Inu Island Ales: "Share. Shakaz. Stories."

46–174 Kahuhipa Street
Kaneohe, HI 96744
@inuislandales

Inu Island Ales is a small, local brewery in Kaneohe on the Windward side of Oahu. It is dedicated to defining the "island ale" style. Its name says it all—*inu* is Hawaiian for "drink."

Kona Brewing Company: "Kona Brews Are Liquid Aloha."

7192 Kalanianole Highway
Honolulu, HI 96825
(808) 396-5662
@konakokopub

This is one of Kona Brewing Company's first expansion brewpubs. Located in the Koko Marina Shopping Center, this location still maintains the original brewing company's passion. Each beer is inspired by the Hawaiian Islands' history, landscape and culture, and each tells a story. Its style and flavors are a taste of Hawaii—easygoing, flavorful, fragrant and refreshing.

Inu Island Ales. *Photograph by the author.*

The brewery invites its customers to discover the story behind the beer as they sip on a pint and enjoy a freshly prepared meal. Its servers, bartenders and brewers love to "talk story."[110]

Lanikai Brewing Company: "Island Inspired"

167 Hamakua Drive
Kailua, HI 96734
@lanikaibrewing

Lanikai Brewing Company takes its inspiration from the island to be an authentic Hawaiian craft beer company, making 100 percent of its brews in Hawaii. Taking its cues from premium, local, rare and exotic ingredients grown by local farmers or foraged across the Pacific, the brewery brings innovative, bold and flavorful beers that beer drinkers will find nowhere else. The brewery is known for often utilizing local native yeast and bacteria. Each beer has a nice, solid head, allowing drinkers to breathe in the flowers and fruits—the same aromas carried by the islands' gentle trade winds.[111]

Lanikai Brewing Company. *Photograph by the author.*

Maui Brewing Company: "Crafted with Passion. Fiercely Local."

Two locations:

2300 Kalakaua Avenue
Honolulu, HI 96815
(808) 843-2739
@mauibrewingco

573 Kailua Road
Kailua, HI 96734
(808) 518-2739
@mauibrewingco

Maui Brewing Company (MBC) expanded from its base on Kihei, Maui, to open two locations on Oahu. One location is on Kalakaua Avenue, in the heart of Waikiki, and the other is in Kailua, the largest town on the

Windward side. MBC's Kalakaua location is in the Waikiki Beachcomber by Outrigger; it features an expansive open-air interior with a family-friendly vibe. The Waikiki location celebrates the brewery's Maui roots and provides plenty of room for soaking in the Hawaiian sun while enjoying handcrafted food and beverages.[112] The Kailua location is the brewery's newest addition, featuring an open-air interior and family-friendly vibe that celebrates the brewery's history, passion for the craft beer way of life and love for its island home.[113]

Olomana Brewing Company:
"Handcrafted Beer with Hawaiian Ingredients"

270 Kuulei Road #101
Kailua, HI 96734
(808) 261-2337
@olomanabrewing

Olomana Brewing Company is part of an emerging trend in craft brewing in the United States. It is a small-batch brewery; each beer is handcrafted thirty gallons at a time. Considered a "nanobrewery" rather than a microbrewery, it allows itself "to try some fun weird things."[114]

Olomana Brewing Company. *Photograph by the author.*

Stewbum and Stonewall Brewing Company: "#pouronthecraft"

96 North King Street
Honolulu, HI 96816
(808) 376-8939
@stewbumandstonewall

Named as a tribute to the friendship and lives of the owners' fathers, Stewbum and Stonewall began as a true nanobrewery and one-man operation, brewing on a two-barrel system three to four days a week. In the beginning, they were able to pump out about twelve kegs of beer each week. They quickly outgrew their warehouse and are now housed in a space that utilizes a ten-barrel brewhouse and twenty-barrel fermenters.[115] Located in the center of Chinatown in downtown Honolulu, it is housed in an old furniture store in the old Lee and Young Building.

Village Bottle Shop and Tasting Room: "A Craft Beer Bottle Shop with Benefits"

675 Auahi Street
Honolulu, HI 96813
(808) 369-0688
@villagebeer

"Village Bottle Shop and Tasting Room is the first dedicated craft beer bottle shop and beer café in the state of Hawai'i." This unique beer venue believes that beer is special and can bring people together as a community. It has a tasting room that it calls a "beer café"; it's laid back and relaxed and is a place where customers can hang out with friends or get some work done, all while enjoying an amazing beer. For a beer geek or beer novice, Village strives to elevate the beer-buying experience by providing a vast selection of inventory and a knowledgeable staff.[116]

The mural above the shop is of Princess Bernice Pauahi Bishop in the various stages of her life. Her estate was used to fund Kamehameha Schools, which owned the location where the shop is currently located.

Stewbum and Stonewall Brewing Company. *Photograph by the author.*

Village Bottle Shop and Tasting Room. *Photograph by the author.*

Waikiki Brewing Company

Two Locations:

1945 Kalakaua Avenue
Honolulu, HI 96815
(808) 946-6590

831 Queen Street
Honolulu, HI 96813
(808) 591-0387
@waikikibrewco

Billed as "Waikiki's first brewery," Waikiki Brewing Company brews premium, fresh, handmade craft beer in its seven-barrel brewhouse. Located at the gateway to Waikiki, the brewery indulges its creativity with seasonal and limited-release beer. All of its beers are brewed on site in full view of the bar.[117] Its Kaka'ako location houses a twenty-barrel brewery.

KAUAI

Kauai Beer Company

4265 Rice Street
Lihue, HI 96766
(808) 245-2337
@kauaibeer

Opened in the fall of 2013, the Kauai Beer Company is a destination for residents and guests. It is a neighborhood microbrewery, which produces artisan batches of high-quality craft beer that it serves in a relaxed atmosphere, making beer lovers feel completely at home.[118]

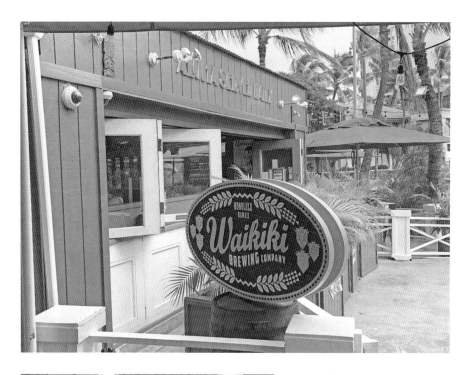

Above: Waikiki Brewing Company on Kalakaua Avenue. *Photograph by the author.*

Left: Janae Souza at Kauai Beer Company. *Photograph by Monique Kan-Souza.*

Kauai Island Brewery and Grill. *Photograph by Monique Kan-Souza.*

Kauai Island Brewing Company:
"World's Westernmost Brewery. The Last Beer Before Tomorrow."

4350 Waialo Road
Port Allen, HI 96705
(808) 335-0006
@kauaiislandbrew

Kauai Island Brewing Company is located in Port Allen, Kauai. As the world's westernmost brewery, Kauai Island Brewing Company was originally Waimea Brewing Company, which was located on the historic Waimea Plantations. When its lease was up, the owners, along with their brewmaster, created Kauai Island Brewing Company and moved to Port Allen, where they now have more space to brew their renowned beers.[119]

Holoholo (To Leisurely Roam)

MAUI

Kohola Brewery

910 Honoapiilani Highway
Lahaina, HI 96761
(808) 868-3198
@koholabrewery

Kohola Brewery is a local, independent craft brewery located in Lahaina. The brewery pours its heart and passion into a pint to share their craft with those who love extraordinary brews. The makers believe that good beer is one of those special things in life that brings people together and makes everything better.[120] *Kohola* is the Hawaiian word for "humpback whale."

Kohola Brewing Company. *Photograph by the author.*

Maui Brewing Company: "Crafted with Passion. Fiercely Local."

Two Locations:

Main Brewery
605 Lipoa Parkway
Kihei, HI 96753
(808) 213-3002
@mauibrewingco

4405 HI-30 Suite 217
Lahaina, HI 96761
(808) 669-3474
@mauibrewingco

Maui Brewing Company brews island-inspired beers. Viewing itself as "fiercely local," it is uncompromising in using the best ingredients from the best sources. Its main brewery in Kihei offers daily tours from its Kihei Tasting Room, which provides an up-close glimpse of its brewing facility, cellar and packaging line.[121]

BIG ISLAND OF HAWAI'I

Big Island Brewhaus: "Food, Craft Beer, People, Music"

64–1066 Mamalahoa Highway
Waimea, HI 96743
(808) 887-1717
@bigislandbrewhaus

According to the website for Big Island Brewhaus, the brewery's "favorite things in life, though not necessarily in this order, are great FOOD; quality CRAFT BEER; fun, creative PEOPLE; and live MUSIC." Big Island Brewhaus is a community gathering spot that combines all these elements for the community and visitors to the Big Island.[122] It is also the state's highest brewery at 2,764 feet above sea level.

Maui Brewing Company in Kihei, Maui. *Photograph by the author.*

Big Island Brewhaus. *Photograph by the author.*

Hilo Brewing and Beverage Company

275 East Kawili Street
Hilo, HI 96720
(808) 934-8211
@hilobrewingco

Established in 2018 from a longstanding tradition of brewing beer in Hilo, Hawaii, the Hilo Brewing Company produces and delivers the highest quality hand crafted beer to our Hilo and Big Island communities, the state of Hawaii and the rest of the world. The Hilo Brewing Company team has combined decades of brewing and beverage experience and prides itself in maintaining the highest quality control standards across brewing, sanitation and, of course, the taste and freshness of our beer. The signature tastes of Hilo Brewing and Beverage Company's beer all begin by using Hawaiian water, which is rated in the top of the country and the rest of the world.[123]

Hilo Brewing and Beverage Company was formerly Mehana Brewing and Hawaii Nui Brewing. The brewery is located in an old Pepsi plant.

Kona Brewing Company: "Liquid Aloha"

74–5612 Pawai Place
Kailua-Kona, HI 96740
(808) 334-2739
@konabrewingco

Kona Brewing Company was founded in 1994; the owners combined their love of Hawai'i and its pristine, natural beauty with their fondness for delicious, local brews. The current brewpub in Kona opened in November 1998. In true Aloha spirit, the pub was constructed using locally sourced materials, with a two-thousand-square-foot outdoor lanai that lets customers kick back and breathe in the fresh island air. Inside the brewpub, customers can spend a few hours lounging at its masterpiece U-shaped Koa wood bar that is made from driftwood that was found at a nearby beach.[124] The brewery only supplies the Islands of Hawai'i with kegged beer. Its new plant will can beer. The restaurant has the only four-star green rating in the state; there are only twenty-nine other restaurants with the same rating nationwide.

Hilo Brewing Company. *Photograph by the author.*

Kona Brewing Company. *Photograph by the author.*

Ola Brew Co.:
"Na Hawai'i, No Hawai'i" (By Hawai'i, For Hawai'i)

74-5598 Luhia Street
Kailua-Kona, HI 96740
(808) 339-3599
@olabrewco

Ola Brew Co.'s mission is to encourage growth in Hawai'i's agricultural economy by purchasing local ingredients and incorporating them into its beers and ciders. Its website lays out the brewery's mission:

> We know that the quality of a product starts with the quality of ingredients. And what better than to use the freshest ingredients from our island. Ola Brew works to increase the demand for local farms not because it looks good on paper, but because we care about our local community, the land we occupy, and drinks that we are providing and distributing to our island community. Ola Brew is both employee- and community-owned. We have 650 small investors and 20 employee owners, which results in dedicated staff and an engaged community.[125]

Ola Brewing Company. *Photograph by the author.*

Holoholo (To Leisurely Roam)

FROM PLACES TO PEOPLE

The breweries, along with their restaurants and their taprooms, offer visitors an immersive experience in the life of Hawai'i and show what the state's people truly value. A refreshing beer is only made better when drinking it in a welcoming, comfortable and warm setting. This atmosphere is part of all the breweries around Hawai'i.

The next part of our journey includes meeting some of the people who have led the adventure and created these inviting places and their tropical brews. To talk story with them is to encounter a devotion to their craft that is as big as the Pacific itself.

TASTING NOTES

Brewery	Date Visited	Beers Sampled	Notes

PART III

Talk Story
(Hang Out and Chat)

6.

"CHANCE 'EM, BRAH!"

Interviews with the Owners
and Brewers of Hawai'i

There's never been a better time to be a beer drinker in Hawai'i. The sheer number and variety of brews being produced and served is like nothing the Islands have ever seen before. The places where beers are made are also like no other place on the planet. As the local saying goes, "Lucky we live Hawai'i!"

There is no doubt that local beer drinkers feel lucky to live in Hawai'i, but the brewers responsible for that feeling also feel lucky. Making beer in Hawai'i may be like nothing else anywhere in the world, but the people making these beers are also like no one else in the world. Producing any beer is a labor of love, but producing it in the center of the Pacific requires even more devotion. These brewers love what they do because they love where they do it. And Hawai'i has embraced them.

The individuals who are working to make Hawai'i a world-class beer location are an eclectic bunch who reflect the well-known mixture of people that make up the Islands' unique population. Some were born and raised in Hawai'i; others were born outside the state but raised in Hawai'i; still others moved to Hawai'i as adults to pursue their dreams of living in paradise. No matter how they came to be in the state, they all share a sense of stewardship for the local craft brewing movement and want to ensure it is part of the *aina* they all love.

The devotion to making brews with the flavors of the Islands has brought out a new band of adventurers who are willing to take risks, to "chance

'em," and see how far they can go. Talking story with the people who make brewing possible in Hawai'i shows how the Aloha spirit is infectious.

These conversations also reflect another important quality of life in Hawai'i—the laid-back feeling of interacting with people. Casual and informal are definitely traits of the people of Hawai'i. Interviewing the key people in today's Hawaiian beer scene could be barely seen as standard and formal. There wasn't a list of questions peppered at someone seated at a table with a recorder running to keep track of each word. Instead, these were true Hawaiian-style talk story sessions, often with beers in hand, wandering through a brewery, sitting bar side or relaxing outside in the sun.

All of these conversations happened just before the outbreak of COVID-19 made in-person meetings difficult. They have also been edited for brevity and clarity. So, grab your favorite a beer, pull up a chair and enjoy some talk story and let the spirit of Aloha wash over you.

CINDY GOLDSTEIN, EXECUTIVE DIRECTOR, HAWAIIAN CRAFT BREWERS GUILD

The Hawaiian Craft Brewers Guild has a big mission. The guild is "dedicated to craft beer brewed 100% in Hawaii." The guild's website states, "The Hawaiian Craft Brewers Guild supports and promotes the common interest of our members through enhancement of consumer awareness of Hawaii craft beer choices in the marketplace, access to the marketplace by Hawaiian breweries, and an equitable system of regulation and taxation."[126] Founded in 2012 to strengthen the community of craft brewers in the state, the guild's membership has grown to include sixteen breweries.

The strengthening of this community is in the hands of Cindy Goldstein. A native of Connecticut, Cindy moved to Hawai'i in the 1990s and, as she says, "never looked back." We met at Nico's Seafood on Pier 38 of Honolulu Harbor, just as a massive container ship was being offloaded in the distance.

AUTHOR. I guess it's karma, but we're watching goods arriving in Hawai'i. Maybe there's some brewing stuff on the dock.

CINDY. [*Laughs*] There could be, but that's one of the issues with brewing in Hawai'i—it's expensive to get stuff here and to get beer to the Mainland, largely because of the Jones Act. It requires all shipped goods traveling

between two U.S. ports to be transported on U.S.-built, -owned and -flagged vessels and with American crews. There are only so many of those shipping companies, and the price is high. Plus, refrigeration is an issue, not just on vessels, but also in warehouses that are near wharves. You can't have cans and kegs of beers sitting out in the heat, waiting to get loaded.

AUTHOR. You've worked as a real advocate for brewers to get costs down. How did you get involved in the guild?

CINDY. I studied plant physiology at the University of Illinois. I moved here and had a home-brewing club, and I retired out of agricultural consulting. The position was interesting. And I'm like Switzerland—I didn't come from any of the breweries, so a lot of the breweries see me as neutral. It helps when [it] comes to advocating for changes in laws.

AUTHOR. You've had some successes lately, too.

CINDY. We were able to amend state laws so that county liquor commissions can't restrict the number of drinks [that] can be served, but it's based on how many ounces [that] can be served per customer. This change allowed breweries on a couple of the outer islands to serve flights. Also, we got a really old law repealed about having tap handles visible from ten feet away. Now, breweries' taprooms can have chalkboard or digital signs. It just made more sense.

AUTHOR. What's your feeling about the current state of brewing in Hawai'i?

CINDY. We're nowhere near saturation, and we have lots of room for growth, but there are some constraints. Space and refrigeration in a state where these things are already expensive are real challenges. A lot of our existing breweries want to expand, but they can rent more warehouses when they'd prefer to expand their existing facilities. Geography in an island state matters.

AUTHOR. How does geography play into consumer demand?

CINDY. In Hawai'i, geography really matters. On Oahu, traffic can be a real pain. People will look for what's nearby. Even on the Big Island; no one

who lives in Kona is going to drive all the way to Hilo for a craft brew. That's why I think we also have more room to grow with breweries. There are parts of the Islands that don't have a brewery yet.

AUTHOR. What do you think people should know about brewing in Hawai'i?

CINDY. Oh, that the breweries we have all have the feeling of being small, local and independent—even Maui Brewing. They truly believe in it, despite all the challenges of doing business in Hawai'i. They are engaged in their communities; they work with nonprofits and fundraisers. And, with the limited space and limited resources, they have to be sustainable and local. It's not just something they slap on a label to sell beer. It's not just a nice thing to do; it's just what you have to do here.

AUTHOR. And, finally, what beer is the best for pairing when you're advocating for the guild?

CINDY. Oh, good question! I'd say a breakfast stout with cacao from Kauai, vanilla from Hawai'i Island, coffee from Maui and wild yeast captured and cultured on Oahu, brewed 100 percent in Hawai'i, of course.

NATHANIAL ANDERSON, HEAD BREWER, WAIKIKI BREWING COMPANY

Watching Nate jump among pulling hoses to fill the mash tun, take beer orders from customers and pour beers would make anyone feel lazy, but that didn't stop him from taking the time to talk about what he loved the most—brewing new beer for his community. He moved back to Hawai'i from Nebraska to make beer. He's been with the Waikiki Brewing Company since it began in 2014. We had a chat at the original Waikiki Brewing Company location on Ala Moana Boulevard and Kalakaua Boulevard as he bounced from brewery to bar.

AUTHOR. How did you become the head brewer at the first and only brewery in Waikiki?

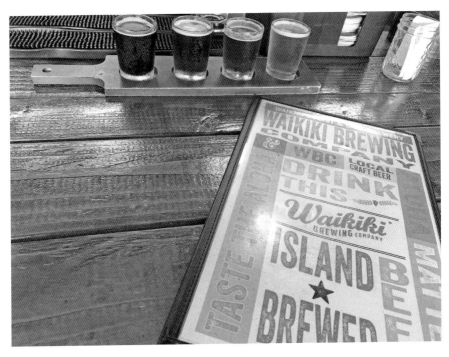

A flight of beers at Waikiki Brewing Company. *Photograph by the author.*

NATE. I started home brewing back in Nebraska but wanted to move back to Hawai'i and brew. I was lucky enough to get with the owners as they were planning the place. I've learned a ton and have been so grateful for the opportunity. I don't see myself going anywhere else.

AUTHOR. A lot of brewers want to start their own place—how about you?

NATE. Not me. It's a pain to go through all the licensing and then finding the location for a brewery. I'm happy to be making great beer right here.

AUTHOR. What's the biggest obstacle to finding a space for a brewery here on Oahu?

NATE. It's where to put it. Most of the breweries are in Kaka'ako, but the buildouts have taken so much time. Brewing capacity gets limited, which makes it tough to not only expand but also make new beers. You have to have space, and here on Oahu, it's limited.

AUTHOR. This is a pretty cool brewing space you've got. What was it before the brewery moved in?

NATE. It was part of a Sizzler Steakhouse. We moved all the brewing tanks into the back. It took some time, that's for sure.

AUTHOR. Now, you've got two other locations. You must feel good about that.

NATE. It's awesome! This location is still the test lab, where we run our experiments and decide what the other locations get.

AUTHOR. Is it tough to ship your beer to other places?

NATE. Not to the outer islands. The refrigerated containers are reliable, but shipping to the Mainland is tough. It's not so much the expense, but I can't guarantee the quality of our product because I don't know if the refrigeration will be consistent from point A to point B.

AUTHOR. A lot of the brewers in Hawai'i's past found that distance was also the big challenge.

NATE. Oh, it still is. The Jones Act just kills us. Puerto Rico, after the hurricane, got relief from the Jones Act. I just hope it doesn't take a disaster here to get some sort of similar treatment.

AUTHOR. That would be nice. Even with some sort of accommodation with the Jones Act, distance would still be a challenge.

NATE. No doubt. So, even if I can get a company to say that they'll ship grain or whatever within ten days, a hurricane anywhere along the route will delay it. Planning out our brewing schedule is never a sure thing.

AUTHOR. As a "test lab" location, what have been some fun beers you've made?

NATE. We made a beer in honor of King Kalakaua's birthday. Since we're right on the boulevard that's named after him, I thought it would be a cool idea. We used some ti root in the brew. The Korriban Coffee IPA uses a local ingredient—Lion's Coffee which is made with beans from Kona. That's been a fun brew. I'd say about 98 percent of our beers'

drinkers are locals. We get a lot of tourists, no doubt. We love being part of the community and want to do more.

AUTHOR. There definitely feels like there's a brewing community here on Oahu.

NATE. Yeah, it's great. We all work well together. I wish we could do more as a community of brewers to help the community we serve.

AUTHOR. If you were king for a day, what would you do to make your life as a local brewer easier?

NATE. Man, good question. I think all of us brewers just want to make good beer. We don't want to be the biggest conglomerate out there. There's so much good local stuff out here now. And the history of fermenting stuff on the Islands goes way back. I'm sure there's got to be some recipes that the *kupuna* [elders] hold on to, but they're not sharing. I totally understand that. So, yeah, at the end of the day, I just want to keep on making beer in the place I love.

KIM BRISSON-LUTZ, BREWMASTER, MAUI BREWING COMPANY

The building that houses the brewery of Maui Brewing Company in Kihei has the brewing power of all of Hawai'i's past breweries combined. And it does it entirely with solar power; the roof is covered with over four thousand solar panels. When combined with the solar panels on the restaurant side, Maui Brewing Company actually gives power back to the grid of the island. In many ways, this is poetic—Maui Brewing Company rests under Mount Haleakala (House of the Rising Sun). The restaurant and lanai areas all boast views of the famous mountain. The brewery is an eighty-thousand-square foot facility that produced sixty-three thousand barrels of beer in 2019, which were distributed to twenty-four American states and four countries. But 80 percent of all the beer it produces is for the Hawaiian market. Its company motto says it all: "Fiercely local."

Kim was in the middle of working a shift when we briefly chatted inside the brewery about how the challenges of making beer on Maui have led the company to adapt its brewing practices in novel ways.

An aerial view of the solar panels at Maui Brewing Company. *Courtesy of Maui Brewing Company.*

AUTHOR. How long have you been with Maui Brewing Company?

KIM. I was initially with the company for five years [but later] took a break to work on a brewery in San Diego. That brewery was acquired by Anheuser-Busch, and I was lucky enough to get hired back here about three years ago.

AUTHOR. What's are some of the differences between brewing here and San Diego?

KIM. Oh, just the distance to get ingredients. In San Diego, I could order a pallet of ingredients and get it within four days. Here, it's anywhere from four to sixteen weeks. It requires us to plan a lot further in advance and to buy larger quantities of ingredients at one time. In San Diego, you can throw a rock and hit a brewery. There was already the infrastructure to support brewing. On Maui, we just have Kohola Brewery to work with on orders. That means I'll order a forty-foot container of ingredients rather than a pallet. We have to stockpile.

AUTHOR. Do you still get to San Diego to check out what that beer scene is producing?

KIM. Yeah, I go often. That's where one of my favorite moments happened. I was touring some breweries, and that's how I met my wife. She's a coffee brewer, and she actually works here to include some coffee in our beers. I guess we're just a brewing couple.

Kim Brisson-Lutz with the author. *Photograph by the author.*

AUTHOR. That's really great that you met through brewing and you're both working together in brewing as well. So, Maui Brewing Company was recently voted as "America's Favorite Solar Powered Craft Brewery" in a Brews from the Sun contest. What else are you working on here to be even more sustainable?

KIM. We do have a [carbon dioxide] collector, which means we have significantly cut down on the need to get [carbon dioxide] from somewhere else. Soon, we'll be collecting 100 percent of it to use in our beers. We have to be so much more self-sufficient out here. It's not just because of the sustainability issues, but being more and more off the grid means we don't have to rely on so many other elements. You have to be creative and innovative to brew in Hawai'i.

Garrett Marrero, Founder and CEO, Maui Brewing Company

Garrett is a tough person to pin down. If he's not working to expand Maui Brewing Company's inventory beyond beer to include soda, hard seltzer, canned cocktails, roasting coffee and distilling liquor, he's either in Honolulu lobbying legislators to make laws that are more favorable to local companies and local industries or he's creating new ways to make Maui Brewing more sustainable. With his energy and attention spread over a wide field, a phone conversation was the best way for him to share his story about his passion for brewing on Maui.

AUTHOR. I had a great conversation with Kim, the brewmaster at MBC, who shared the story about the brewery's sustainability and its future contribution to the island of Maui. What made you think that Maui would be a good fit for making beer?

GARRETT. Maui is such an awesome place. When I would come here, I would drink out-of-state beers because that was the only thing available. I always thought, "Why doesn't such a beautiful place have its own beer?" I mean, beer enhances good experiences and vice versa. If you think about how different a beer tastes when you're at the beach or outside, it's about the experience. Maui deserved good beer.

AUTHOR. When you look back on those early days when you were brewing for a brewpub on Maui, did you think that you'd ever be bringing so much great beer to the island, to the state and beyond?

GARRETT. Oh, it was hard, hard work. No doubt. There was nothing easy about it. There were costs, and I'm not just talking financially. There were personal and professional costs; you put in so many hours and so much sweat to bring a dream to life. But when the first can of Big Swell came off the line, I knew we had reached a tipping point.

AUTHOR. What other tipping points do you think were part of Maui Brewing's story?

GARRETT. In 2006, we won a World Beer Cup Medal. That was great. And, of course, when we built the Kihei facility with a brewery and restaurant

that is completely solar powered. Not only were we growing, but we were leading by example and with sustainability.

AUTHOR. And, this year [2020], MBC is celebrating its fifteenth anniversary. Congratulations!

GARRETT. Thanks! The celebration was great! It was great to see how many people have had different relationships with our beer over fifteen years. And, honestly, I couldn't have done it without my wife, Melanie; she's been such a strong part of bringing this dream into reality.

AUTHOR. What are your hopes for the future of Maui Brewing and brewing in the state of Hawai'i?

GARRETT. I guess I have three hopes. One is that we in the state make the highest-quality beer available for everyone to enjoy. The second would be better inter-brewery communication and collaboration. There's so much talent out there, and we can work together a lot better to improve the industry in our state and to get a better share of the beer market. I think we can also work together to protect the "Hawai'i" brand as well. The third is solar brewing. We can do so much more to have every brewery solar powered. We owe it to the state and to future generations.

Postscript

During the early outbreak of COVID-19, Maui Brewing Company's Kupu Spirits Distillery made hand sanitizer for healthcare workers and first responders while giving it to customers for free.

NICOLAS WONG, CO-OWNER, BEER LAB HAWAII

At the University Boulevard location of Beer Lab Hawaii, in the same area where Nick went to high school, the conversation was as freewheeling and wildly enthusiastic as his brewery's philosophy. Beer Lab folks like to have fun and share it with their customers—or as Nick calls them, "our community." His wife, Kailey, joined us at the table as she worked on the brewery's books on her laptop. Nick is one of the few brewery owners in the state who was

born and raised in Hawai'i. It definitely influences his passion to bring beer to other parts of Oahu that haven't yet experienced "local, fresh beer." Still, experimentation is at the heart of Beer Lab's brewing passion, too. While it doesn't take a nuclear scientist to make and experiment with beer, it doesn't hurt to be one. Nick and the other two owners knew each other from their time working for the U.S. Navy as nuclear engineers. Experimentation is part of who they are.

AUTHOR. So, you guys are kinda' the mad scientists of local beer brewing.

NICK. [*Laughing*] I guess you could say that. We really like to keep things rotating frequently. You would think customers would want some standard favorites, but we've found that our community comes in looking for what's new that we're doing. They try it out and spread the word. It's been one of the biggest positive experiences—having a community of folks who regularly come in to support our new stuff. It's great because we know we've done it right because they're not just buying beer, but they're spreading the word. Plus, our employees love it here. We have the same employees we started with; we've had no turnover. They even hang out here when they're not working.

AUTHOR. That's awesome. It's kind of a different model than a lot of craft breweries that have a flagship beer, experiment here and there and then distribute their best sellers in kegs and bottles. Does constantly having new brews affect plans for distribution?

NICK. Not really—we're not into fighting for shelf space. We're not into doing large-scale canning. We're not looking to take over the world. We just want to have fun and brew. We figure that expanding the number of our locations is how we answer the distribution question. More locations means more people drinking our beer and having a good time.

AUTHOR. What's the craziest brew you've made?

NICK. I'm not sure it was crazy, but I really liked doing our lemongrass sour. Some farmers were going to plow it over and just asked if we'd like to use it. We said, "Sure!" It was awesome. We're probably going to work with farmers more often. Our Waipio location is like twenty minutes from the "country." It makes sense for us to work together.

AUTHOR. You guys had an interesting beginning. Before you started Beer Lab Hawaii, your friend Kevin Teruyo was recovering from a triathlon injury and used the time to home brew. You and another buddy, Derek Toguchi, were his guinea pigs. Then, all of you began to think about opening a place on Oahu. From your biography, it seems like the beer bug got to you when you toured Dogfish Head in Delaware. It's kind of wild—you took your experience from the "first state" to the fiftieth state.

NICK. I loved the Dogfish Head vibe, and I thought this is exactly what Oahu needed—a place for people to relax, do something fun and try a really different beer. I also loved their beer and lots of the beer from the East Coast. It was impossible to get it in Hawai'i, so I thought, "Why not just brew it ourselves back in Hawai'i?"

AUTHOR. The brewing scene in Hawai'i seems to be pretty crowded though, especially on Oahu.

NICK. Well, we're not in it to "win." Winning for us is to keep on brewing for our community. That's our goal. Again, we're not in it to take over the world. We don't want any other brewery to fail. That doesn't help Beer Lab. In fact, I think there's still a lot more room for beer. I don't mean, like, in volume or for more Honolulu breweries. Our other locations in Pearl City and Waipio are reaching a whole new population who don't really know what local, fresh beer tastes like. They like Coors and Heineken, but not everyone on the Westside or North Shore wants to come all the way into Kaka'ako to try a craft beer. I could see new breweries in those areas of the island.

AUTHOR. You're kinda' like brewing missionaries rather than mad scientists.

NICK. [*Laughing*] Yeah, you might be right. Oahu is a small place, and word of mouth matters.

AUTHOR. True. I mean, guess who I met by chance yesterday at Hana Koa Brewing Company? Your former intermediate school math teacher!

NICK. No way! Mr. Souza! Yeah, there you go. He comes in from time to time. One moment, he's my teacher, and now, he's one of my customers.

AUTHOR. Yeah, that's a total Hawai'i story. I know; it's wild. And this chalkboard mural over by the tables is wild, too.

NICK. That was done by Peter Nguyen, who draws for Marvel. He's a friend of Derek's wife, Kellie. He came by and asked if we wanted to be superheroes. So, he went ahead and drew us that way [*laughing*].

AUTHOR. That's really cool! Hey, what was here in this location before Beer Lab?

NICK. This was a Bank of Hawaii. The bar is where the tellers' counter was; the tanks are where the vault was; and just behind them was the safe deposit boxes. It was vacant for three years after it left. Nobody wanted the space…. We said, "Um, we'll take it."

AUTHOR. That's another totally Hawaii thing—just chance 'em and see what happens.

A superhero mural of the Beer Lab's owners. *Photograph by the author.*

Nicolas Wong and the author. *Photograph by the author.*

Alfred Hocking's house. *Photograph by the author.*

NICK. For sure. We love what we're doing, and we want to keep on running. That's our idea of "winning," to just keep on going, to keep having fun and bringing the community more beer that they'll love.

Postscript

Nick graduated from Roosevelt High School in Honolulu, just down the street from the former house of Alfred Hocking, the founder of Primo Beer. Nick was walking in the shadow of a brewing giant each time he passed it in high school.

DAVID CAMPBELL, DIRECTOR OF OPERATIONS AND HEAD BREWMASTER, ALOHA BEER COMPANY

If anyone could be labeled the "godfather" of Hawai'i's craft brew movement, it would be David Campbell. He started home brewing in the 1990s and eventually opened Big Aloha Brewing in Sam Choy's first restaurant, from which Aloha Beer Company emerged. He's been a part of brewing challenges and successes across the state for over twenty-five years. He's also a keen beer historian of Hawai'i's past beers, which makes sense; after all, he was a history major and was raised on Oahu. Even his current endeavor exudes the history that he loves and respects. Aloha Beer Company is located in Kaka'ako, just up the street from the Honolulu Brewing and Malting Company building; he has a large picture of the top of that building prominently displayed in the taproom. His brewery is in the same place where his father-in-law made suntan lotion in the 1970s until the late 1980s. The conversation upstairs in the new bar and lounge area was about the early days of craft brewing in the state, David's love of history and the pride he has in his craft.

AUTHOR. So, talking to others in the local brewing community, you're often called the "godfather."

DAVE. [*Laughing*] Maybe "pioneer" is better. I was definitely here at the beginning with a lot of other guys. Those early days were great because it was just our small little community of home brewers trying to figure everything out. We definitely blazed some trails in the early 1990s.

Kegs of Aloha Beer. *Photograph by the author.*

AUTHOR. Tell me about what excites you the most about those days.

DAVE. Definitely the community of small brewers. It was this obscure, hobby scene, and we all knew each other, but we wanted to turn more people on to what we were brewing. It wasn't easy. I managed to find a space behind the old Flamingo Chuckwagon restaurant. In that part of town at that time, there were lots of *braddah-braddahs*, but I figured it out. I started Oahu Homebrew in 1994, where I'd sell equipment, give classes and brewed my own stuff for the taproom. I loved how people would come in and just talk story over some beers. Sam Choy found out about us, came in, drank beer, talked story and then said, "Let's start some brewing at my place."

AUTHOR. You're a local boy—how did you get bitten by the brewing bug? You and I are the same age; growing up here, there wasn't any local stuff. We were all drinking Heineken, Coors, Rainier.

DAVE. Oh, yeah. I remember. Well, my dad brought a home-brewing kit back from the United Kingdom when I was in high school. My brother

got totally into the science of it all. I kept brewing through college at the University of Hawai'i, and then I transferred out to Oregon. I was doing way too much surfing, and I needed to get my degree. I maybe surfed three times out there, but I kept brewing there, too. But the microbrewing scene was really taking off, and the beers were delicious. I wanted to come back home and brew the stuff like they were making in Eugene and Portland.

AUTHOR. Even starting a home-brew place in Hawai'i must've been difficult back then.

DAVE. For sure. Hawai'i is a hard place for beer. Lease rent is expensive; utilities are expensive. But what we do have is great water. The quality is amazing. But now, the industry is not going away. It's not like the early days, when we had to convince people to try something that wasn't from off island and to spend money on a beer of better flavor. They're already convinced now, and we don't have to try hard and "convert" people to our beers.

AUTHOR. Hawai'i's beer history is all about the challenges of distance, market and politics, isn't it?

DAVE. Yeah, that's about right. I'd add culture, too. Lots of Mainland people can't adjust to the culture shock of Hawai'i when they want to move out here and live the dream of brewing. My brewing mentor, Paul Farnsworth, is a Brit, and one thing he always said is that brewing back in the distant past was always local. Breweries were meant to be close to the source of the ingredients they used and the people they served. You knew the people in the community and the ingredients. You pretty much got what you could for ingredients and distributed your brew based on how far your horse could draw a cart. I still firmly believe that. I wanted to be the local community beer guy. You hear a lot about "hyper-localism" of people only going to their nearby brewery, but that's the way it was in the past. There's nothing wrong with that. I'm stoked to be doing what I love.

AUTHOR. I can see how your love of history and the *aina* are connected to what you do.

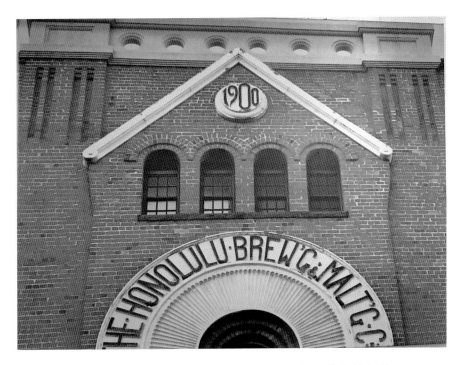

A painting of Honolulu Brewing and Malting Company on the wall of Aloha Beer Company. *Photograph by the author.*

DAVE. Absolutely, I see Aloha Beer Company being about two things. One, we're going to be true to Hawai'i and its culture. I'm not going to do any labeling or branding that will disrespect our traditions in any way. I still think history is important, and we have to honor those who came before us. If you look just behind the bar, you see I still have a rotary dial phone on the wall. It's to remind everyone here of the past and to remind people of hard work. I mean, back in the day, you had to work just to make a simple phone call. [*Laughing*] Two, we're going to be true to the craft. I'm going to make clean- and balanced-tasting beers with simple ingredients. We're not going to get caught in the rip current of faddish stuff. I'm also not planning on doing any big distribution out of state. I want to keep it all local and be the local, community brewery. And my love of history is why I wanted to be in Kaka'ako; it's the historic brewing district of Honolulu.

AUTHOR. Kaka'ako has definitely changed. I remember the only time I came down here as a kid was when my dad used to drag my sister and me here

to find some hard-to-find spare part that he needed so he could repair a broken appliance in the house.

DAVE. Right! You only came down here to get something fixed or find something to fix something else. But our buildout and our plans to expand are going to totally respect the area's past vibe. We don't want to lose some of the area's soul.

Postscript

Dave actually helped as Primo was being reintroduced to Hawai'i when part of it was brewed on Kauai in the early 2000s. With his brewery surrounded by the pre- and post-Prohibition breweries of Primo, he has brought Hawai'i's beer history full circle.

KEAKA ECKERT, CO-OWNER, AND KYLE MACDONALD, HEAD BREWER, INU ISLAND ALES

Located in a light industrial section of Kaneohe on the Windward side of Oahu, with a garage door as a main entrance and beer taps in a 1,200-square-foot space, Inu Island Ales looks like a place that a beer drinker would love to win on *Storage Wars*. It may be small, but Inu has a powerful following in the beer trading community. They are a hub for the local area and for beer enthusiasts across Oahu. As they opened for the day, Keaka and Kyle shared the story of Inu.

AUTHOR. So, what is "beer trading?" Is it sort of like trading baseball cards but for beer fans?

KEAKA. Sort of. Yeah, lots of people want to try new beers from around the world. In Hawai'i, it's hard to get a lot of the good craft beers from the Mainland. What people here will do is grab some of our canned beer, put it in a flat-rate box then trade it with someone on the Mainland who has a different beer that they want. Of course, it's a good way for our beer to reach the Mainland without having to go through a huge distribution chain.

Barside at Inu with Keaka Eckert, Kyle MacDonald and a customer named Kevin. *Photograph by the author.*

AUTHOR. That's pretty cool. How did you decide on beer trading as a model for Inu?

KEAKA. I was into beer trading before we opened Inu. My brother was big into Deschutes's beers, but you couldn't get them in Hawai'i at the time. We'd have to bring it back with us when we went to the Mainland. Plus, I'd be going back and forth to San Diego and seeing what they were doing on the beer front and figured I could brew back in Hawai'i. I still go to as many Mainland beer festivals as possible to see what the trends are. We definitely want to appeal to the younger crowd; I always want us to be on the front of the wave. Most of our community is really active on social media, and that's how a lot of marketing is done. Our fans share pics with us, and we post them. And when we have a new release, the line is fifty to one hundred people around the side of the building. I love it.

AUTHOR. Are those your favorite moments?

KEAKA. Yeah, those beer releases are totally fun. It's a real community hanging out and talking story.

AUTHOR. That's part of your motto: "Share. Shakaz. Stories." How did you come up with that?

KEAKA. "Share" because that's what beer trading is all about. "Shakaz" because it's Hawai'i [*laughing*]. "Stories" because that's what people do when they get here; they're just talking with one another about other beers to trade and how to do it.

[*At that moment, a regular customer walks up and asks, "Hey, do you have anything new? I love a good sour." After pouring him an Inu Island Punch Peach and Apricot, the conversation continues.*]

AUTHOR. How did you get this space for brewing? Why not down in Kaka'ako?

KEAKA. This was the original Stewbum and Stonewall Brewery. They outgrew it, and it became available, so it was perfect timing for us when we were looking for a place to start Inu.

AUTHOR. Kyle, you were brewing in Northern California before you came here. Was it a big transition?

KYLE. I wouldn't say there was any big transition. I have to do a lot more cleaning and maintenance here [*laughing*]. The heat and humidity mean there's always something to be done. But brewing, I get to do a lot more hazy IPAs and sours here than what I was doing back in Sacramento.

AUTHOR. Any big differences between here and the Mainland?

KYLE. Definitely the local fruits I get to work with. The hazies I make are so pillowy soft.

AUTHOR. What does the future hold for you guys and Inu?

KYLE. Probably doing some Belgian style beers—we'll see.

KEAKA. Oh, I'd definitely like a bigger space [*laughing*].

A flight of beer at Inu. *Photograph by the author.*

The men's room of Inu, with labels of traded beers lining the walls. *Photograph by the author.*

HAWAI'I BEER

GEOFF SEIDEMAN, OWNER, HONOLULU BEERWORKS

Joining Geoff as he was brewing a South Shore Stout in the early afternoon was a lesson in juggling the success of a growing business that feels like it is bursting with growing even more. Geoff opened Honolulu Beerworks in Kaka'ako in 2014, when the second wave of craft brewing was building in the Islands after the early wave of microbrewing had waned. Since he opened, he's been going nonstop to meet the demand for his beer.

AUTHOR. So, you're originally from Philadelphia. How did you and your wife decide to pick up and leave Pennsylvania and brew here?

GEOFF. I was tired of the cold [*laughs*]. Well, I always liked island life, and my wife had been here before. I was an auto mechanic in Philly, and then I herniated two discs. We decided to take trip here and then moved soon after. I've always been interested in culinary stuff, so I worked in that field here, and my wife worked at Town and Country Surf Shop. Then I got a home-brew kit. I was into that. I ended up becoming a brewing assistant

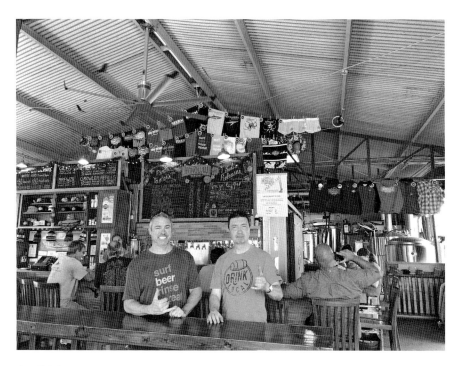

Geoff Seideman with the author. *Photograph by the author.*

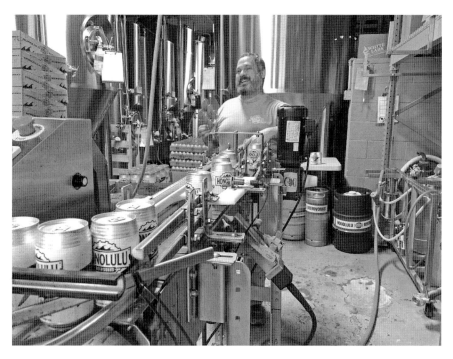

The canning line at Honolulu Beerworks. *Photograph by the author.*

to Dave Campbell at Big Aloha in Sam Choy's restaurant. And then I opened up this place. It's great because I get to combine two things I love: mechanical stuff and culinary stuff.

AUTHOR. You were really on the bow wave as craft brewing was taking off here recently.

GEOFF. Yeah, it was really just Gordon Biersch that was here on Oahu when I started. Sam Choy's had folded. It made it tough. Ingredients were hard to get. Gordon Biersch could combine their grain and hops shipments in the same container as their food shipments. We couldn't do that. Kona Brewing was also going, but their shipments were all bound for the Big Island. We started small. I mean, people were sitting next to grain bags in our taproom when we first opened. And now, last year [2019], we did 1.7 million cans of beer.

AUTHOR. That's amazing!

GEOFF. And we're nowhere near meeting our demand. Airlines want our product, and hotels have been a big demand. Tourists want to drink something local while they're eating something locally made. Why get a beer they can get at home—even a craft beer—when they can get something that's freshly made just down the street in Kaka'ako. Hotels are now coming to us, rather than a few years ago, when we were lucky to get a meeting with any of their beverage managers or the distributors that worked with the hotels.

AUTHOR. What about the Mainland? Are you supplying there?

GEOFF. We can't even meet demand here. We'd like to at some point, and we'll probably start on the West Coast. Looking west for us is also a possibility—Japan likes our stuff. I've been to a few beer festivals in Japan and was a judge at one in Yokohama.

AUTHOR. And you're only five years old!

GEOFF. It's been amazing, and we love it. My favorite things are our anniversaries. They're real tributes to our staff and our customers who've really kept us growing. That was my vision. I mean, Oahu is the "Gathering Place," and that's what we wanted to do—have people gather here. I don't care if you're a blue-collar worker, a politician from down the street at the capitol building or a Japanese tourist—come here and have a beer and talk story.

AUTHOR. So, what's next? You've got a lot going on with all your success.

GEOFF. Definitely getting a production warehouse set up, probably in Kapolei. We'll keep the taproom and the lab here. We want to be at the forefront of styles and ingredients. We've done barrel-aged beers, which was a new thing in Honolulu. We want to keep making good beers that people will enjoy in a place we love.

Talk Story (Hang Out and Chat)

STEVE HAUMSCHILD, CEO AND BREWMASTER, LANIKAI BREWING COMPANY

Steve rolls up to the bar on a skateboard to meet for our conversation. After shaking hands, it's Steve who asks the first question—"Hey, do you want a beer?" We split a bottle of Mauka to Makai Chocolate Haupia Imperial Stout. He is an energetic explorer of the frontiers of beer making, a bioprospector of wild yeast around the state that can be fermented. With three science degrees from the Ohio State University, after his final degree, the only available job in the United States that sounded interesting to him was an extinctionist position at Volcano National Park on the Big Island. Ironically, after the 9/11 funding cuts to the park service, his position became extinct. But with an adventurer's spirit, he landed in Oahu and soon after began Lanikai Brewing Company.

AUTHOR. Well, I guess you are my hometown brewery. I'm a Kailua boy—I graduated from Kailua High School and grew up in Aikahi. How did you end up here?

STEVE. It's a long story. I'm from the Midwest originally and got job with the U.S. Park Service on the Big Island. I didn't know much about Hawai'i before coming here. I thought it was all *Brady Bunch* haunted tiki stuff [*laughing*]. After my job on the Big Island went away, I was convinced to come to Oahu. I hadn't been to Oahu in the four years I was on the Big Island. But I came to Hawai'i because I needed to explore, so I figured, "Why not check out Oahu?" I did a lot of expeditionary education before. I worked at a kayak company here in Kailua, and then, in two years, I owned it. I then got an MBA from the University of Hawai'i. One of my projects was to build a business plan. I came up with the idea of how to make a brewery that was less wasteful.

AUTHOR. Were you into brewing before your MBA project?

STEVE. I had a friend who was into home brewing at the same time I was fixing surfboards. We began to exchange skills. So, I didn't really come from a brewery background before I started Lanikai. That meant I didn't have any habits to break and that I could look at things with different eyes. I thought about how to make an ecologically sustainable brewery. Brewing is extraordinarily wasteful. I eventually built the first fully electric

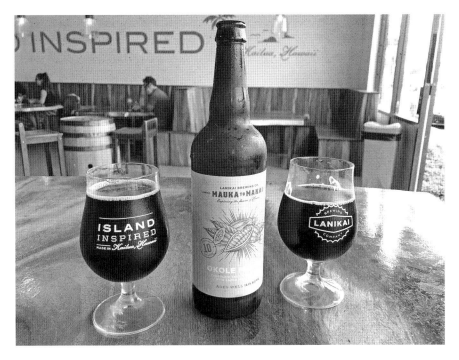

A bottle of Mauka to Makai Chocolate Haupia Imperial Stout, Lanikai Brewing Company. *Photograph by the author.*

commercial brewery and constructed the equipment without buying the usual off-the-shelf stuff.

AUTHOR. How has that been working out?

STEVE. Really well. Our commitment to sustainability and less waste has meant that we only have two fifty-five-gallon trashcans. We empty them about four times a year; we throw them on the back of a pick-up truck. We don't even own a dumpster. We also don't can our beers; we bottle them. Bottles are 100 percent recyclable, but cans are only 75 percent recyclable. I'm still trying to crack the code on water usage though. It's about four gallons of water to produce a gallon of beer. I'd like to figure out a way to bring that down, but I haven't yet.

AUTHOR. That is one of the inherent challenges in making beer anywhere. What's unique about Hawai'i when it comes to brewing challenges?

Talk Story (Hang Out and Chat)

STEVE. No doubt its tax rate. Brewers here pay about 50 percent more in taxes than on the Mainland. I can't really pass that down to the consumer because then they won't drink my beers. The Jones Act also limits us. Even though there are so many brewers in the state, we can't combine shipments in the same container with brewers on the outer islands and vice versa because they'd have to unload and repack it. That would eliminate any savings and potentially lead to spoilage while the shipments are waiting on the ship or on the dock. The good news is that we are a real industry now. In another world, the breweries would be competitors—not in Hawai'i. We have worked together to pass legislation and to find ways to let people know about beer in our state.

AUTHOR. Tell me about your bioprospecting wild yeast strains in the state.

STEVE. Yeah, so not all beers that are made in Hawai'i are "Hawaiian beers" in the sense of using as many local ingredients as possible. You don't get more local than using indigenous microorganisms to ferment beer.

Decorative bottles, Lanikai Brewing Company. *Photograph by the author.*

I've even gone so far as to collect yeast strains by swabbing the bellies of different sharks—hammerheads, sandbars. I worked with the University of Hawai'i under the biosampling permit to do it. It was cool.

AUTHOR. But that wasn't the wildest thing you've done as a bioprospector. I read about your use of "space yeast." How did that happen?

STEVE. By complete accident! I didn't plan on ever working with NASA to brew beer [*laughs*]. But I was subbing in a race on the Big Island, and my partner was with NASA. He told a few of his colleagues to come into Lanikai Brewing. When they did, I kinda' joked with them. "Hey, if I'm going to be the first brewer on Mars, I'm going to need some space yeast." They didn't really laugh at it. But then they began to talk about ways about how to do it. There have always been these ER-2 space flights to do monitoring of coral depletion or volcanic activity, for example. With no cost to the taxpayer, I gave them some sample collectors, and at seventy thousand feet, they collected some samples. Some were unusable or mixed. We separated a few of the mixed samples, and the scientists had never seen them before. So, they were UFOs—unidentified fermenting objects. I brewed the first "space beer." I was totally nervous about the whole project of sending something with the space flight; I didn't want to be known as the brewer who destroyed NASA [*laughing*].

AUTHOR. And you brewed with the UFO?

STEVE. We actually used it in a beer to mark the fiftieth anniversary of the moon landing. We had to go through a lot of protocols before. I mean, we didn't even know if these "UFOs" were fit for human consumption or even if they would work in the fermentation process.

AUTHOR. Someone in my hometown actually came up with space beer! How did you choose Kailua for your brewery?

STEVE. Well, I was living here, and I loved it. Also, there wasn't a locally owned brewery on this side of the island. Hawai'i still has a lot of room to grow when it comes to craft beer consumption. I think it's like 95 percent of the beer consumed in the state comes from out of state; that's only 5 percent for craft brews. On the Mainland, the market penetration for craft beer is something like 18 percent. But Kailua was growing, and I saw

lots of potential in this town. Plus, we have all this great plant life; I get to work with some great ingredients. And it's a small town still, and everyone kinda knows everyone. So, a friend of mine who owns a coconut tree trimming company gives me all the coconuts he would normally discard. I use them in some of our brews.

AUTHOR. From the belly of sharks to the stratosphere, what's the next frontier for Lanikai Brewing?

STEVE. I would really love to still crack the code on water consumption when brewing beer. I really want to bring that ratio down. Barring that, I'd love to have a beer with each one of our customers and staff who have really brought Lanikai Brewing into what it is today. That's the best collaboration I've worked on.

MATTSON DAVIS, FORMER PRESIDENT AND CEO, KONA BREWING COMPANY

In 1994, father and son, Cameron Healy and Spoon Khalsa, founded Kona Brewing Company on the Big Island of Hawai'i. In 1997, Mattson Davis was brought in to oversee operations and grow the brand. In 2010, the Craft Brew Alliance (CBA) purchased Kona Brewing Company. (CBA is a merger between Portland, Oregon's Widmer Brothers Brewing and Woodinville, Washington's Redhook Ale Brewery. At the time, AB InBev owned 31.2 percent of the Craft Brew Alliance). Mattson left the company in 2015, four years before AB InBev bought the remaining shares of Kona Brewing from CBA. But in 2020, Kona Brewing Company's Hawai'i operations were sold to a Delaware company, allowing AB InBev to buy CBA. Although according to the standards of the Brewers Association, Kona Brewing is not considered a "craft beer" brewer, its contribution to the history of Hawai'i beer cannot be overlooked.

As one of the architects of the most successful beer brands in Hawai'i's history, Mattson arrived for our conversation in front of Kona Brewing Company's restaurant. "Hey, I have to drive up to Waikoloa to get napkins for Magic's [a restaurant he now owns]. Want to come?" So, we piled into his car and talked about the early days of Kona Brewing Company.

Mattson Davis and the author. *Photograph by the author.*

AUTHOR. Kona's beers are now some of the most recognizable around the United States and around the world. Kona Brewing didn't come out of the box ready to go for success. What were some of your early challenges?

MATTSON. Honestly, the founders were not prepared for the sheer costs involved in starting something like a brewery on the Big Island. Both Cameron and Spoon loved coming to the Big Island on vacation and then thought about how great it would be to open a brewery here. But when I came on board, I saw that we were losing on money on every case of beer we sold—bottle costs, shipping, electricity, water. We had some quality issues when we tried bottle fermenting in this climate; the caps kept blowing off [*laughs*]. That's when I thought about contract brewing with other breweries on the Mainland. They had capacity, and it turned out that it was also more eco-friendly rather than shipping our beers to the Mainland. Kona still supplies Hawai'i with kegs, but it stopped bottling here a while ago.

AUTHOR. You were really more active than simply auditing the books.

MATTSON. Oh, for sure! I was also building the brand. We had the advantage of using Kona in our name. It has a certain "stickiness" as a brand because it's already associated with a premium product—Kona Coffee. I told people to try Kona's other "brew," and they got it. But when I would travel out of state, I would walk around in Olukai sandals. I also packed a supply of two things to hand out to people—aluminum gecko bottle openers and Hawai'i state quarters. I gave them out to people to start the conversation about Hawai'i and Kona beers. But, as you know, giving and generosity is part of our culture in Hawai'i. It was an example of Aloha and not just marketing. Honestly, in those days, I spent maybe 10 to 12 percent of my time talking about beer and the rest just talking about Hawai'i. It was a hell of a lot of fun.

AUTHOR. What was the most fun moment you've had where if you could relive it again, you'd do it in a heartbeat?

MATTSON. Oh, good question! I'd have to say it's the concerts we'd have in our backyard, which is really the parking lot of Kona Brewing Company and the pub. We had Collective Soul and just a bunch of great musicians play under a big Hawaiian sky; people had plastic Kona Brewing Company cups with our beer in them. There was just a great energy and magic.

AUTHOR. How did you know that you were all on to something with Kona Brewing—that you had reached a tipping point?

MATTSON. Probably three things: When we were contracted with Duke's TS Restaurants to brew an exclusive beer for them, Duke's Blonde. We were doing about one hundred kegs per month! The second would be when we got alternating proprietorships to brew beer. And, finally, when the two other smaller breweries in Hawai'i at the time—Ali'i Brewing and Trade Winds—were gone, and we were still standing.

AUTHOR. It sounds like that was attributable to your building of the brand.

MATTSON. That was an important direction, where I tried to steer the company. I wasn't going to put any grass skirts or coconut shell bras on our labeling. That's just insulting. We used recognizable landscapes, like Diamond Head or Pipeline, to bring people to the brand. And, of course, sharing Aloha. I even had the Kona Brewing pickup truck

designed to be recognized around the island as I was collecting kegs or whatever. I gave so many people rides in the back of it. "Want a ride? Jump in." They could all say, "I just rode with the Kona beer guy!" Beer has a remarkable currency of its own. People celebrate with beer. Just think about all the times when there was going to be a party and you or someone else said, "I'll bring the beer." It was a great feeling. I mean, you could've just said, "Here's twenty bucks; go buy something." But showing up with a couple of six-packs is so much more valuable at a personal level.

AUTHOR. There has been the issue that Kona beers made here are only for Hawai'i, while Kona beers sold on the Mainland are made there.

MATTSON. Well, it was still in keeping with our belief in freshly made local beer with a low carbon footprint. Using existing brewing facilities on the Mainland to make our beer for that market drastically reduced the amount of waste and the sheer number of pallets, containers and vessels that we would've needed to ship our beer from here to the Mainland to supply the existing market at that time.

Kona Brewing Company and a truck. *Photograph by the author.*

Kona Brewing Company's new facility under construction. *Photograph by the author.*

AUTHOR. Kona is getting ready to share a lot more beer around the Islands with the new facility that is being built.

MATTSON. It will be amazing. I like to think that technology has finally caught up with beer making in Hawai'i. Beer making will become so much more efficient and with a lower carbon footprint. The new facility will use only one-fifth of the water the current brewery is using now. It will use reverse osmosis as part of the process. It will be able to extract much more from each load of grain, reducing the freight costs. It will also have a biodigester that will provide 40 percent of the power for the facility; another 30 percent will come from solar power.

AUTHOR. It really is incredible how far we've come in the history of island beer brewing. Now that you're no longer with Kona Brewing, what wish do you have when you look at the brewing scene today?

MATTSON. I really wish we could do something about the Jones Act. I know a lot people's livelihoods depend on it, so I don't want to trash it, but maybe make some kind of amendments to it. Other than that, I guess I have a broader wish, which is for people to slow down a bit, step back and take a look around from time to time. In a word, "Aloha." We need more of it.

Afterword

Imua

(Moving Ahead with Strength)

So, what did you feel? Was it the love we have for the *aina* or the diversity we treasure? Was it the spirit of Aloha as each challenge of brewing in the middle of the Pacific was overcome and transformed into an innovation? Whatever you felt, it's something none of the brewers in the Islands have taken for granted—past or present.

There are so many diverse ways to produce a wide variety of styles and flavors of beer on our many different islands. But they are still beers, and Hawai'i's beers are part of the overlooked history of American brewing. And yet, they are a reflection of *e pluribus unum*—out of many, one. You don't get much more American than that.

Hawai'i's beers are now reaching the wider world. Foreign visitors to the state savor the unique local beers; the brews themselves have been recognized in beer festivals around the world. Brewers in Hawai'i aren't merely playing along the shore break of the global craft beer movement; they are out there in the big surf. And that's where the adventure lies, navigating a big ocean. Think about the experiences of those who've made brews in Hawai'i: brewing beer in the face of a mutinous crew off the coast of an unknown land; making a barrel of beer while being the advisor to the first king of Hawai'i; trying to make a commercial brewery work in a place without ice or refrigeration; surviving as brewery during prohibitions and world wars; starting life anew as a brewer after changing jobs, losing a career or recovering from a physical injury; building a brewery that's entirely solar powered; opening a new brewery as a global pandemic rages; collecting space yeast!

A view of Kailua Beach, Oahu, at sunrise. *Photograph by the author.*

In the Gabby Pahinui song "Waimanalo Blues," there are the lyrics: "The beaches they sell to build their hotels my fathers and I once knew." It's a lament about all the places in old Hawai'i that we're losing to development. The lyrics are also a warning to the current generation to take care of the land for the *keiki* (children); we don't want to lose paradise to rampant commercialism. We don't want to look like every other place in the world.

But Hawai'i still faces challenges in heeding this warning—the high cost of living and doing business in the state has meant that the Islands have joined the handful of other U.S. states that are losing population due to out-migration. In addition, tourism and development comprise too much of our state's economy, limiting many career opportunities and curtailing needed diversification. That's why the craft beer movement is so important to Hawai'i and the direction of the state's future. Too many of us are getting lost in the hustle and bustle of daily life. Hawai'i's craft breweries' emphasis on innovation, sustainability and remaining local helps to remind us of our links to the *aina* and of our origins as adventurers.

So, where does the next adventure lie in the future of Hawai'i's beer? It's most likely somewhere between the memories of the Hawai'i that once

was and the dreams of the Hawai'i that could be. Beer is one of humanity's oldest comfort foods. When combined with the land of Aloha, it offers an inviting shelter from the storms of a complicated world. Whether you find peace in the foam of a beer or the foam of the surf (or both), Hawai'i's brewers will welcome you—with a refreshing, cold beer.

For joining this part of the adventure of brewing in paradise, we say sincerely, "*Mahalo nui loa*," and "*okole maluna!*"

Timeline of Selected Events in Hawai'i's Brewing History, 1778–2007

Pre-Kingdom

1788: Captain James Cook brews a beer made from sugarcane and hops aboard the HMS *Discovery*, anchored in Kealakekua Bay, Hawai'i.

Kingdom of Hawaii (1795–1893)

1812: Spaniard Don Francisco de Paula Marin (who was referred to by his Hawaiian name, Manini) notes in his journal that he made a barrel of beer. It is Hawai'i's first recorded brewing of beer onshore.

1815: Manini records in his journal that he made another barrel of beer. He notes that this beer was for his friend Captain John Tyler.

1848: King Kamehameha III initiates the Great Mahele, ending the ancient Hawaiian land tenure system and permitting the private ownership of land for businesses like breweries.

1850: The first recorded shipment of ice arrives in Hawai'i, allowing for the cold conditioning of lager beer.

1854: Honolulu Brewery opens as Hawai'i's first commercial brewery in downtown Honolulu. It closed in 1856.

March 1865: Hawaiian Brewery opens and produces the first recorded lager in the Islands. It closed in December 1865.

July 1865: Oahu Brewery opens after a rift in the partnership of Hawaiian Brewery. It closed in 1866.

1887: National Brewery announces that its brewery in Kalihi will be open to the public for inspection and will begin operations the following day.

1888: National Brewery announces that it is producing steam beer at its brewery. It closed in 1893.

REPUBLIC OF HAWAII (1894–1898)

1897–1898: Honolulu industrialist Alfred Hocking begins planning to found a new commercial brewery in the city.

1898: Alfred Hocking founds Honolulu Brewing Company but lacks a building. He changes the brewery's name to Honolulu Brewing and Malting Company.

TERRITORY OF HAWAII (1900–1959)

1900: Honolulu Brewing and Malting Company begins construction on its brewing facility on Queen Street.

1901: Honolulu Brewing and Malting Company releases the first batch of Primo Beer, which is the first American beer made in the Islands.

1912: Honolulu Brewing and Malting Company hires Hartwig Harders from Pabst Brewing to improve its brewing operations, upgrade the recipe for its signature Primo brand and launch a new brand called Salvator.

1918: Prohibition begins in Hawai'i. Honolulu Brewing and Malting Company closes its doors in 1920.

1920: The Jones Act is passed, requiring only U.S.-owned and operated vessels to take shipments to and from U.S. ports. This increased the costs of all goods that were coming to and leaving Hawaii.

1933: Prohibition ends on December 5. American Brewing Company is organized.

April 1934: American Brewing Company releases Pale Ambrew and takes over the Honolulu Brewing and Malting Company's shuttered facility on Queen Street.

May 1934: Hawaii Brewing Corporation reintroduces Primo, with a new $300,000 brewery built at Cooke Street and Kapiolani Boulevard.

1938: A fifty-day strike at the Hawaii Brewing Corporation's Pearl City Brewery results in it becoming a union-only plant.

1941: Hawai'i is again subject to Prohibition after the attack on Pearl Harbor. The military governor lifts Prohibition in February the following year.

1958: Hawaii Brewing Corporation is the first brewery to sell beer in an aluminum can; Primo is canned in the "Shiny Steiny."

STATE OF HAWAI'I (1959–PRESENT)

1962: Hawaii Brewing Corporation is renamed Hawaii Brewing Company. American Brewing Company, the makers of Royal Beer, closes.

1964: Jos. Schlitz Brewing Company of Milwaukee purchases Hawaii Brewing Company and takes over production of Primo.

1966: The production of Primo is moved to a $5 million, eight-acre brewing facility in Pearl City.

1969: This is the peak of Primo's popularity. It captures 70 percent of the local beer consumer market, selling nearly two million cases.

1974: Schlitz completes a $2 million renovation of the Pearl City Brewery.

1978: President Jimmy Carter signs a bill to permit the home brewing of beer, sparking the microbrewing movement. State deregulation of brewpubs soon follows in a number of states in the United States.

1979: Schlitz rolls out the last cases of Primo made in Pearl City and moves the beer's production to its Los Angeles facility.

1982: Stroh Brewery Company of Detroit purchases Jos. Schlitz Brewing Company. It changes Primo from brown to green bottles and moves its production to Texas.

1985: Pacific Brewing Company opens in Wailuku, Maui, becoming the first microbrewery in the state. It closes in 1990.

1994: Mainland brewpub chain Gordon Biersch opens a franchise at Aloha Tower Marketplace in Honolulu; it closed in 2020. Ali'i Brewing Company in Honolulu becomes the first microbrewery in the state since the closure of Pacific Brewing Company; it closed in 2001. Oahu Homebrew opens as supply store with a small taproom in Kaka'ako, Oahu. Kona Brewing Company opens on the Big Island of Hawai'i.

1995: Trade Winds Brewing Company opens in Maui; it is purchased by Kona Brewing Company in 2001.

1997: Sam Choy's Big Aloha Brewery opens as the first locally owned Honolulu brewpub. It's the precursor of the Aloha Beer Company, which

was founded in 2012. Fish and Game Brewing Company and Rotisserie opens on Maui; it's the forerunner of Maui Brewing Company, which opened in 2004. Whaler's Brewpub is the first beer brewery to open on Kauai; it closed in 2005.

1998: Schlitz ceases the production of Primo. Keoki Brewing Company opens on Kauai; its parent company Hawaii Nui Brewing Company merges it with Mehana Brewing Company and renames it Hawaii Nui Brewing in 2008.

1999: Pabst Brewing Company purchases assets from Stroh's, including the Primo brand.

2000: Moloka'i Brewing Company opens the first brewery in the island's history; it closed the following year.

2004: Maui Brewing Company emerges from the Fish and Game Brewery and Rotisserie.

2007: Pabst Brewing Company reintroduces Primo for the twenty-first century.

Da Kine

Beer Terms

alcohol by volume (ABV). The measurement of the alcohol content of a solution in terms of the percentage volume of alcohol. The measurement is always higher than alcohol by weight (ABW) and is used to calculate the taxation of a type of brewed beer. To calculate ABV, subtract the final gravity from the original gravity and divide by 0.0075.

alcohol by weight (ABW). The measurement of the alcohol content of a solution in terms of the percentage of weight of alcohol. To calculate the ABW of beer, subtract the final gravity from the original gravity and divide by 0.0095.

ale. A beer made from top-fermenting yeast. It is typically, but not always, fermented at warmer temperatures than lager beers. Examples of types of ales include: stouts, India pale ales (IPAs) and pale ales.

barley. A cereal grain used in the production of beer.

barrel. A measurement of beer, usually 31.5 gallons or two standard kegs.

bitterness. In beer, bitterness is created with the use of hops. The amount of bitterness often determines the style of a beer. For example, IPAs are considered to have the most bitter flavor and aroma of any type of beer.

bottle conditioned. The process in which beer is naturally carbonated in the bottle as the result of ongoing fermentation due to the intentional addition of wort or sugar during bottling.

bottom fermentation. One of two basic fermentation methods characterized by yeast cells that sink to the bottom of a fermentation container. Lager yeast is an example of a bottom-fermenting yeast, while ale yeast is a top-fermenting yeast.

Brettanomyces. A type of yeast that ferments sugar and produces flavor in many styles of beers. It adds acidity and creates earthy flavors and aromas. Belgian lambic-style beers along with barrel-aged styles commonly employ this type of yeast.

brew kettle. A critical vessel used to boil the wort, and it's where hops are often added.

carbonation. A process by which carbon dioxide is created during the fermentation process or introduced into the finished product. It gives beer its fizz, foam and froth.

cask. A barrel-shaped container usually made of oak staves and bound with iron bands used for holding beer.

cask conditioned. A technique in which unfiltered, unpasteurized beer is stored in casks, then kept in cool areas between forty-eight and fifty-six degrees Fahrenheit. Flavors from the casks become part of the beer's flavor, and carbonation builds naturally.

craft brewery. The Brewers Association defines a craft brewery as a small, independent and traditional company that makes beer. "Small" means having an annual production of beer under six million barrels. "Independent" means less than 25 percent of the brewery is owned or controlled by an alcoholic beverage industry member who is not a craft brewer. "Traditional" means a brewery that has an all-malt flagship beer (one that represents the greatest volume among the brewery's brands or styles).

dry hopping. The addition of hops in the late stages of the brewing process to increase the hop aroma of a finished beer without adding greater bitterness.

fermentation. The chemical conversion of sugars into ethyl alcohol and carbon dioxide through the interaction of yeast.

flight. A sample tray of small servings of beer. Many craft breweries, where lawful, will sell a set of individual smaller glasses of beers for customers to get an appreciation of a brewery's offerings.

fresh hopping. The addition of newly harvested hops that have not been dried to different stages of the brewing process. This adds unique flavors and aromas to beer that are not normally found when using dried or processed hops. Also known as "wet hopping."

growler. A half-gallon or two-litter jug-like container used to carry out draft beer from a bar, tavern, brewery or restaurant.

hopping. The addition of hops to either wort or fermented beer.

hops. A perennial climbing vine that has been used for brewing beer since the ninth century. A relative of cannabis.

international bitterness units (IBU). A measurement of the bittering substances in beer, which often depends on the style of beer. Beers with low IBUs are typically light lagers, while India pale ales have higher IBUs.

keg. An aluminum container used to store and serve beer. In the past, kegs were wooden barrels. A standard keg can also be a unit of measurement, usually 15.5 gallons, which is also referred to as a "half-barrel" keg.

lager. A beer that uses bottom-fermenting yeast at colder temperatures. Lager comes from the German word meaning "to store." Lager beers were typically stored in caves during the winter to help with fermentation.

lagering. Storing bottom-fermenting beers in cold rooms for days to years.

lautering. The process of separating pre-boil wort from the spent grain with a straining apparatus.

lautering tun. A large vessel with a perforated false bottom and a drain spigot in which the mash is allowed to settle and the wort is removed from the grains through a straining process.

malt barley. A process by which barley or other cereal grains are steeped in water to force them to germinate so that they can be dried in such a way to produce soluble sugar. For beer making, this provides one basis for fermentation, and it adds flavors and aromas to beer.

mash. A mixture of ground or milled grain and hot water that is known as wort.

mash tun. A vessel in which wort is produced.

nano brewery. A type of craft brewery that specializes in small-scale brewing of under approximately three barrels per batch and under two thousand barrels per year.

rotating tap. A term used in bars, pubs, taprooms and restaurants for draft beer taps that are not reserved for a particular type of beer. Instead, many beers are cycled through over time.

session. Typically, a low ABV beer that can be consumed in larger quantities over time with minimal risk of drunkenness.

sixtel. A small, narrow keg often used by craft brewers. It contains 5.16 gallons of beer.

sour. An acidic or tart flavor in beers that is produced from either certain yeast strains or bacteria.

sparging. Rinsing or showering mashed grains in the mash tun in order to get the remaining sugars for the wort.

three-tier system. A nickname for franchise laws that govern the distribution of alcohol to the public. For beer, it means a brewery must

sell its product to a distributor that will then sell it to retailers that will then sell it to the public.

wort. The sugar solution produced by warming malted cereal grains in the mash tun. The solution is then transferred to a boil kettle, where hops are added.

yeast. A microorganism that feeds on the sugars in the wort to produce alcohol and carbon dioxide during fermentation. Different yeast strains are used to produce different styles and flavors of beers.

zymurgy. The process of fermentation in beer brewing.

Glossary of Hawaiian and Pidgin English (Hawaiian Creole English)

aina (Hawaiian): land

ali'i (Hawaiian): royal chief in ancient Hawai'i and during the early years of the Kingdom of Hawaii

brah (Pidgin): brother or "bro," long form is "braddah"

chance 'em (Pidgin): "give it a shot" or "take a chance"

da kine (Pidgin): "You know what I mean," or, "You know what I'm referring to."

hele (Hawaiian): "to go" or "moving on"

kama'aina (Hawaiian): Literally "person of the land," which means someone local to Hawai'i.

kanaka maoli (Hawaiian): a person of Hawaiian ancestry

kane (Hawaiian): man

kupuna (Hawaiian): elders

mahalo (Hawaiian): Thank you.

mahalo nui loa (Hawaiian): Thank you very much.

Mainland: the continental United States

no ka oi (Hawaiian): the best

ohana (Hawaiian): family

okole maluna (Hawaiian): Literally, "bottoms up," but it's meant as "cheers" when toasting.

ono (Hawaiian): delicious

pau (Hawaiian): finished, done, over

pau hana (Hawaiian): finished working or done at work for the day

pono (Hawaiian): righteous or righteously

shaka (Pidgin): A hand gesture with the pinky and thumb that is referred to as "hang loose." There is no literal translation, but it is often used to say thanks or as a greeting.

shoots (Pidgin): "Let's do it!"

wahine (Hawaiian): woman

Notes

Introduction

1. Stubbs, "Captain Cook's Beer," 133.
2. King, "Supplement," 503.
3. Dye, "Gift Exchange," 280.
4. Ibid.
5. Pre-contact Hawaiians mashed sweet potatoes and mixed them with water to ferment an alcoholic beverage called ʻuala ʻawaʻawa. Because it was not boiled, ʻuala ʻawaʻawa is not considered to be brewed.
6. This is based on early mapping.
7. Ibid.
8. Hucklebridge, *United States*, 8.
9. Hobart, *Foodways*, 2.
10. Laudan, "Homegrown Cuisines," 12.
11. Michael B. Sauter, "Which State's Residents Drink the Most Beer? Brews News You Can Use for Your Next Bar Bet," *USA Today*, May 2, 2018, www.usatoday.com.
12. Brewers Association, "State Craft Beer Sales & Production Statistics, 2019," www.brewersassociation.org.
13. Gupta, "Dairy's Decline," 60.
14. Anthony Pignataro, "How the War Between Maui Brewing Company and Kona Brewing Company Over What It Means to Be a Local Beer

Spilled Over into the Hawaii State Legislature," Maui Time, March 7, 2013, www.mauitime.com.

15. Gupta, "Dairy's Decline," 65.

16. Garmella, *Drugs and Alcohol*, 300, 338.

17. Laudan, "Homegrown Cuisines," 23.

18. Malerweiny, *Hawaiian Slang*, 16.

19. Loke and Sun Leung, "Competing Food Concepts," 1–11.

20. United States Department of Agriculture, "Hawaii Fact Sheet," USDA Farm Agency, 2011.

Chapter 1

21. *Honolulu Star-Bulletin*, November 7, 1953, 47.

22. Ibid.

23. Spanish Food, "History of Beer," www.spanish-food.org.

24. Hucklebridge, *United States*.

25. Gast and Conrad, *Don Francisco*, 18.

26. Ibid.

27. Ibid.

28. Ibid.

Chapter 2

29. *Polynesian*, March 25, 1854, 182.

30. Department of Geography, University of Hawaii, *Atlas*, 104.

31. Hawaiian Government, *Penal Code*, 101.

32. U.S. Congress, House of Representatives, Subcommittee of the Committee on the Territories, *To Provide for the Prohibition of Liquors in the Territory of Hawaii*, Sixty-Fourth Congress, first session, 1916, 8–9.

33. Gavan Daws, *Shoal of Time, A History of the Hawaiian Islands* (Honolulu: University of Hawai'i Press, 1968), 103.

34. *Pacific Commercial Advertiser* (Honolulu, HI), December 11, 1902, 12.

35. *Saturday Press* (Honolulu, HI), March 4, 1882, 2.

36. Ibid.

37. *Hawaiian Gazette* (Honolulu, HI), January 24, 1883, 2.

38. U.S. Congress, House of Representatives, Subcommittee of the Committee on the Territories, *To Provide for the Prohibition of Liquors in the Territory of Hawaii*, Sixty-Fourth Congress, first session, 1916, 9.

39. Schmitt, "Hawai'i's Beers," 144.

40. Morrison, "Boston Traders," 177.

41. Notice and advertisement, *Polynesian*, November 16, 1850, 108.

42. *Pacific Commercial Advertiser*, September 23, 1865, 3.

43. Ibid.

44. *Pacific Commercial Advertiser*, September 30, 1865, 3.

45. *Pacific Commercial Advertiser*, December 23, 1865, 3; February 10, 1866, 2.

46. *Pacific Commercial Advertiser*, February 17, 1866, 3.

47. Hobart, "Snowy Mountaineers," 476.

48. Schmitt, "Hawai'i's Beers," 144.

49. Huckelbridge, *United States*, 241.

50. *Pacific Commercial Advertiser*, April 13, 1888, 3.

51. Ibid.

52. "The National Brewery: Description of the Buildings and Plant," *Pacific Commercial Advertiser*, November 1, 1887.

53. *Pacific Commercial Advertiser*, June 2, 1887.

54. *Daily Bulletin*, October 21, 1887.

55. *Pacific Commercial Advertiser*, October 31, 1887.

56. *Pacific Commercial Advertiser*, November 1, 1887.

57. *Pacific Commercial Advertiser*, February 1, 1892.

58. *Pacific Commercial Advertiser*, November 1, 1887.

59. "The National Brewery," *Pacific Commercial Advertiser*, January 10, 1888.

60. *Pacific Commercial Advertiser*, January 11, 1888.

61. *Hawaiian Gazette*, January 17, 1888, 5.

62. Ibid.

63. Ibid.

64. *Pacific Commercial Advertiser*, January 9, 1892.

65. "Republic of Hawaii," chapter 41, in *Penal Code*.

66. *Hawaiian Star*, November 23, 1898, 3.

67. *Hawaiian Star*, December 9, 1898, 1.

68. "Beer," *Hawaiian Star*, December 10, 1898, 4.

69. Ibid.

70. "Schweitzer Talks About His Manila Brewery Plan," *Pacific Commercial Advertiser*, December 12, 1905, 1.

71. Nicol, "Kaka'ako," 50.

72. "New Brew Master Will Make Honolulu Beer World Famous," *Evening Bulletin*, February 13, 1912, 2.

73. *Garden Island*, August 13, 1912, 2.

74. "Honolulu Brewery in New Venture," *Honolulu Advertiser*, February 11, 192, 11.

75. The author is grateful to Allan Spitzer of Kailua, Hawai'i, Hartwig Harder's grandnephew, for sharing his great-uncle's biography and supporting materials.

76. J.W. Wadman, "The History of Prohibition in Hawaii," *Friend*, March 1920, 62–3; Ralph Kuykendall, *Hawaii in the World War* (Honolulu: Historical Commission, 1928).

77. Anita Manning, "Prohibition becomes Patriotism," Hawai'i World War I Centennial Task Force, 2018. www.worldwar1centennial.org/index.php/hawaii-wwi-centennial-articles/1179-the-great-war-prohibition-becomes-patriotism.html

78. "Schweitzer Talks," 1.

79. Martyn Cornell, "A Short History of Beer in Hong Kong," *Brewery History* 156 (2014): 8.

80. "Officers Continue Prohibition Raids," *Garden Island*, July 26, 1922, 1; "Flying Squad Arrests 6 in 8 Raids," *Honolulu Advertiser*, May 28, 1928, 1.

81. "Japanese Beer Is Here," *Evening Bulletin*, October 9, 1896, 5.

82. "T. Sumida and Co. Offer Wide Choice of Japanese Beer," *Honolulu Advertiser*, May 5, 1933, 2.

83. *Honolulu Advertiser*, May 4, 1933, 5.

84. *Honolulu Advertiser*, May 11, 1934, 4.

85. Tsutsumi, *Beer Book*, 4.

86. "Deny Council Opposes Strike," *Honolulu Star-Bulletin*, December 23, 1938, 4; "Picketing Continues," *Honolulu Star-Bulletin*, December 30, 1938, 5.

87. "Frank Locey Named Brewery Manager as Verne Burgess Quits," *Honolulu Star-Bulletin*, December 23, 1938, 1.

88. Center for Labor Education and Research, University of Hawai'i, "Timeline of Hawai'i Labor History," www.hawaii.edu.

Chapter 3

89. Byrne, "Beer Can." The cans were pulled from the market because of structural issues, including inadequate lining.

90. Waters, "Primo," 33.

91. Schmitt, "Hawai'i's Beers," 148.

92. "Travel: On to the Outer Islands," *Time*, December 16, 1966, www.content.time.com.

93. Tsutsumi, *Beer Book*, 11.
94. Kaser, "Newest Beer," B-5.
95. Schmitt, "Hawai'i's Beers," 148.
96. Cindy Goldstein, interview by the author, October 26, 2019.
97. Ibid.
98. Brewers Association, "State Craft Beer Sales and Production Statistics, 2018," www.brewersassociation.org.
99. Lee Breslouer, "The Most Interesting Beers in Hawaii Never Reach the Mainland," Vinepair, May 16, 2019, www.vinepair.com.
100. Anderson, "Hawai'i On Tap."
101. "Hawaii Brewers Find Strength in Numbers," *Honolulu Star-Advertiser*, March 13, 2018, www.staradvertiser.com.
102. Alexander Gates, "Aloha Oe: What Real Gastropub Meant to the Hawai'i Beer Scene," Frolic Hawai'i, June 24, 2020, www.frolichawaii.com.
103. "Hawaii Brewers," *Honolulu Star-Advertiser*.

Chapter 4

104. Tanigawa, "Craft Beers."

Chapter 5

105. Aloha Beer Company, www.alohabeer.com.
106. Beer Lab Hawaii, www.beerlabhi.com.
107. ONEninetynine, "Grace in Growlers," www.oneninetynine.org.
108. Hana Koa Brewing Co., www.hanakoabrewing.com.
109. Honolulu Beerworks, www.honolulubeerworks.com.
110. Kona Brewing Co., www.konabrewingco.com.
111. Lankikai Brewing Co., www.lanikaibrewing.com.
112. Maui Brewing Co., "#MBCWaikiki," www.mbcrestaurants.com.
113. Maui Brewing Co., "#MBCKailua," www.mbcrestaurants.com.
114. Facebook, "Olomana Brewing Co.," www.facebook.com/olomanabrewing.
115. Stewbum and Stonewall Brewing Co., "The Story," www.stewbumandstonewall.com.
116. Village Bottle Shop and Tasting Room, www.villagebeerhawaii.com.
117. Waikiki Brewing Co., "Kaka'ako Brew Pub," www.waikikibrewing.com.
118. Kauai Beer Co., www.kauaibeer.com.

119. Kaua'i Island Brewing Co., www.kauaiislandbrewing.com.
120. Kohola Brewery, www.koholabrewery.com.
121. Maui Brewing Co., "#MBCKihei," www.mbcrestaurants.com.
122. Big Island Brewhaus, www.bigislandbrewhaus.com.
123. Hilo Brewing Co., www.hilobrewingco.com.
124. Kona Brewing Co., "Visit Kona Brewing Hawaii," www.konabrewingco.com.
125. Ola Brew Co., www.olabrewco.com.

Chapter 6

126. Hawaiian Craft Brewers Guild, www.hawaiibeer.org.

Bibliography

Anderson, Karen. "Hawai'i On Tap: Local Craft Beer Scene Continues to Flow." *Edible: Hawaiian Islands*, Fall 2017.

Byrne, Brendan. "The Rise of the Beer Can." *Atlantic*, May 27, 2016. www.theatlantic.com.

Department of Geography, University of Hawaii. *Atlas of Hawaii*. Honolulu: University Press of Hawaii, 1972.

Dye, Thomas. "Gift Exchange and Interpretations of Captain Cook in the Traditional Kingdoms of the Hawaiian Islands." *Journal of Pacific History* 46, no. 3 (2011): 275–92.

Garmella, Juan F. *Drugs and Alcohol in the Pacific*. New York: Routledge, 2002.

Gast, Ross, and Agnes Conrad. *Don Francisco de Paula Marin: A Biography/The Letters and Journal*. Honolulu: Hawaiian Historical Society, 1973.

Gupta, Clare. "Dairy's Decline and the Politics of 'Local' Milk in Hawai'i." In *Foodways of Hawai'i*. Edited by Hi'ilei Julia Hobart. New York: Routledge, 2018.

Hawaiian Government. *Penal Code of the Hawaiian Islands*. Honolulu: Hawaiian Government Press, 1850.

Hobart, Hi'ilei Julia. *Foodways of Hawai'i*. New York: Routledge, 2018.

———. "Snowy Mountaineers and Soda Waters: Honolulu and Its Age of Ice Importation." *Food, Culture and Society* 19, no. 4 (2016): 461–83.

Hucklebridge, Dane. *United States of Beer*. New York: HarperCollins, 2016.

Kaser, Thomas. "Isles' Newest Beer Already Can't Meet Demand." *Honolulu Advertiser*, August 24, 1986.

King, James. "Supplement to Cook's Journal." In *The Journals of Captain Cook*, vol. 3, part 1, edited by J.C. Beaglehole. New York: Cambridge University Press, 1961.

Laudan, Rachel. "Homegrown Cuisines or Naturalized Cuisines? The History of Food in Hawaii and Hawaii's Place in Food History." In *Foodways of Hawai'i*, edited by Hi'ilei Julia Hobart. New York: Routledge, 2018.

Loke, Matthew, and Ping Sun Leung. "Competing Food Concepts— Implications for Hawaii, USA." *Food and Energy Security* 2, no. 3 (2013): 174–84.

Malerweiny, Adam S. *Hawaiian Slang: Words, Phrases and Medical Terms in Current Use*. Wailuku, HI: Self-published, 1935.

Morrison, S.E. "Boston Traders in Hawaiian Islands, 1789–1823." *Washington Historical Quarterly* 12, no. 3 (1921): 166–201.

Nicol, Brian. "Kaka'ako: People, Places and Plans." In *Hawai'i Chronicles II*, edited by Bob Dye. Honolulu: University of Hawaii Press, 1998.

Schmitt, Robert. "Hawai'i's Beers and Brewers." *Hawaiian Journal of History* 31 (1997): 143–59.

Stubbs, Brett J. "Captain Cook's Beer: The Antiscorbutic Use of Malt and Beer in Late 18th Century Sea Voyages." *Asia-Pacific Journal of Clinical Nutrition* 12, no. 2 (2003): 129–37.

Tanigawa, Noe. "Bring on Honolulu's Craft Beers." Aired August 11, 2017, by Hawai'i Public Radio. www.hawaiipublicradio.org.

Tsutsumi, Cheryl Chee. *The Hawaii Beer Book*. Honolulu: Watermark Publishing, 2007.

United States Department of Agriculture. "Hawaii Fact Sheet." USDA Farm Agency, 2011.

Waters, Mark. "Primo Irons Out Production Ills." *Honolulu Star-Bulletin*, September 10, 1961.

ABOUT THE AUTHOR

 Paul Kan grew up in Hawai'i, learning its unique traditions, culture and history. He currently splits his time between Hawai'i and Pennsylvania, where he owns Burd's Nest Brewing Company. With a local background in Hawai'i and the eye of a craft brewer, he has been a dedicated follower of the robust craft brewing movement in his home state. When he's not drinking or brewing beer, he's working as a professor of national security studies at the U.S. Army War College.